ICON

ART OF THE WINE LABEL

ICON

ART OF THE WINE LABEL

A Collection of Work by

JEFFREY CALDEWEY *and* CHUCK HOUSE

Foreword by Robert Mondavi
A Brief History by Hugh Johnson

Photography by Robert M. Bruno

The Wine Appreciation Guild
S. San Francisco

First Published in North America by:
The Wine Appreciation Guild, 360 Swift Ave., South San Francisco CA 94080
(800) 231-9463 info@wineappreciation.com

ISBN 1-891267-30-2
Library of Congress Number: 2003104080

Although all reasonable care has been taken in the preparation of this book, neither the publisher nor the authors
can accept any liability for any consequences arising from the use thereof or the permission contained therein.

Art Director: Jeffrey Caldewey Design: Icon Design Group
Editor: K. Page Sparhawk *(Jeffrey Caldewey and Chuck House)*
Production: Samantha Smith Photography: Robert M. Bruno

Printed and Bound in China

TABLE OF CONTENTS

FOREWORD

Robert Mondavi

The collection of labels in this book chronicles the history of an industry. There would be no story of the wine label without the story of the California wine renaissance. At Robert Mondavi, our labels chronicle not only our own history, but the unique history and evolution of the California wine industry, beginning in 1966 when we began the Robert Mondavi Winery. We knew at the time that we had the grapes, the climate, and the grape varieties to make wines on par with any in the world. Our challenge was how to convey that message; our solution was a new kind of wine label.

Beautiful, but indistinguishable from one another, the legacy of the traditional, old-world wine label underwent a revolutionary transformation in California. Labels began to reflect the artistic expression of the wines, and the individual personalities of California's new breed of winemaker. As the quality of our wines improved, the art of the wine label was called on to communicate our advances.

Prior to the 1960s, designing wine labels was not a profession, and printers produced millions of generic labels on which wineries would overprint or rubber stamp the winery's name, type of wine, and vintage. To discover who produced a wine or its place of origin required scouring the fine print. Even the elegant, hand-engraved labels of the Old World emphasized the winemaking region over the unique character of the wine and its producer.

The original Robert Mondavi label, designed by our printer Jimmy Beard and artist Malette Dean, helped

1968
Napa Valley
CABERNET SAUVIGNON
ALCOHOL 12% BY VOLUME
PRODUCED AND BOTTLED BY
ROBERT MONDAVI WINERY
OAKVILLE, CALIFORNIA

establish the winery's reputation and reinforce a new way of thinking—a new way of thinking that would be embodied and championed by designers Jeffrey Caldewey and Chuck House. With careers that parallel the rise of the California wine industry, Caldewey and House have shaped and influenced the evolution of the international wine label, and developed the concept of the wine package as both a work of art and a commercial enterprise.

Congratulations to them, and to publisher Elliott Mackey, who has been an educational pioneer in our fascinating wine community. I know you will enjoy this visually stunning and interesting contribution to any wine library.

12

A BRIEF HISTORY

Hugh Johnson

One glance at the label is worth ten years experience. The words of a skeptic in a tasting room, but true on every level nonetheless. You won't get much for a bottle of wine without a label, no matter what the wine. For all practical purposes the label is the wine's identity.

From the moment wine was first sold in bottles, or even stored in amphoras, it made sense to give it a tag. What the tag said determined its value, its destination, who would open it, and when. The little amphoras stocked in Tutankhamun's tomb were inscribed with vintage, vineyard, and winemaker—one Kha'y by name. How else would the sommeliers of the hereafter know which wine to pour?

We can only speculate about Greek and Roman wine labels. They certainly existed, but they were not the most durable of classical creations. Amphoras from Pompeii were stamped in clay with the traders' names. How they signaled their contents, we don't know.

Pliny was the great wine connoisseur of first century Rome. The legendary wine of his time was Falernian. This pre-Imperial vintage, as notorious as a '47 Cheval Blanc or a Waterloo Port, was referred to as the "Opimiam" because Opimius was consul at the time of its first growth inception. Although there are suspicions about whether this extraordinary wine really existed at all—or even if it was a wine, as I suspect it may have been more of a cocktail—you may be sure the bottle was no ordinary one. The label alone was probably solid gold.

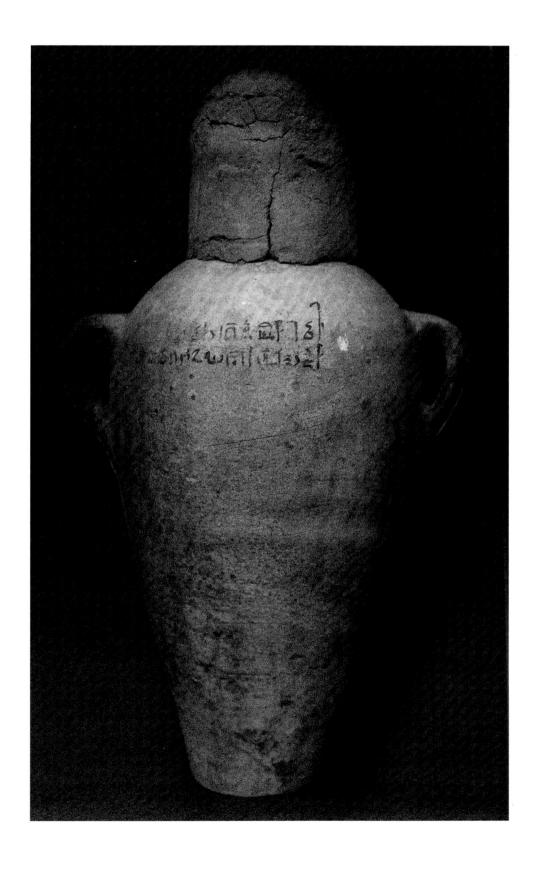

The first wine labels of the modern age were occasionally gold, more usually silver. They were the 'bottle tickets' on chains made to hang round the necks of decanters. Their designs were fanciful; their legends a generalized 'Port' or 'Lisbon.' Working bottles stored in bins still had no labels: the identity of the wine was its bin or its barrel. But in the days when wine was bought by the barrel, it was rare for any cellar to offer much variety.

Who invented the label as we know it? We don't know who invented the corkscrew either—though the two would seem to go hand in hand. The label was slow to arrive. There was no durable, non-absorbent paper. There was no glue to stick it to glass. Even as late as Thomas Jefferson's time the paper label was unknown. The first growth Bordeaux Jefferson bought was put in bottles and engraved with the initials—not of the wine—but of its buyer, Thos J.

The earliest label in my collection—dated 1870—is 'Prince Metternich's Castle Johannisberg, First Growth.' It was bottled by a Frankfurt merchant,

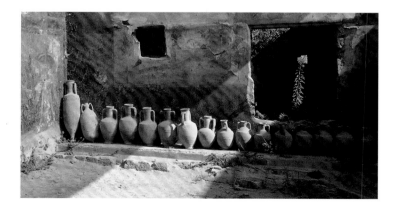

Manskopf, 'By special appointment to the Emperor of Germany.' In 1870, merchants were still responsible for bottling and labeling wine; chateau bottling would be far in the future.

It was Germany that had the prettiest, most richly engraved of the early labels, and its wines—along with Hungarian Tokay—the most prestige and highest prices. Most French labels were designed and run off by the local jobbing printer. Indeed, their provincial family likeness often continues to this day, and is part of their charm. Bordeaux tends to typographic austerity—especially in the Médoc. But Margaux labels sometimes indulge in touches of gold, and Sauternes labels are often printed entirely in gold. The Cote d'Or, less wisely, goes for a faux-parchment effect, popular with printers down the Rhone and along the Loire.

These prototype labels were more about status than individuality. Some—the Bordeaux First Growths in particular—were so well designed that only minor changes have ever been made. But the role of a modern label is as different as today's producers are dis-

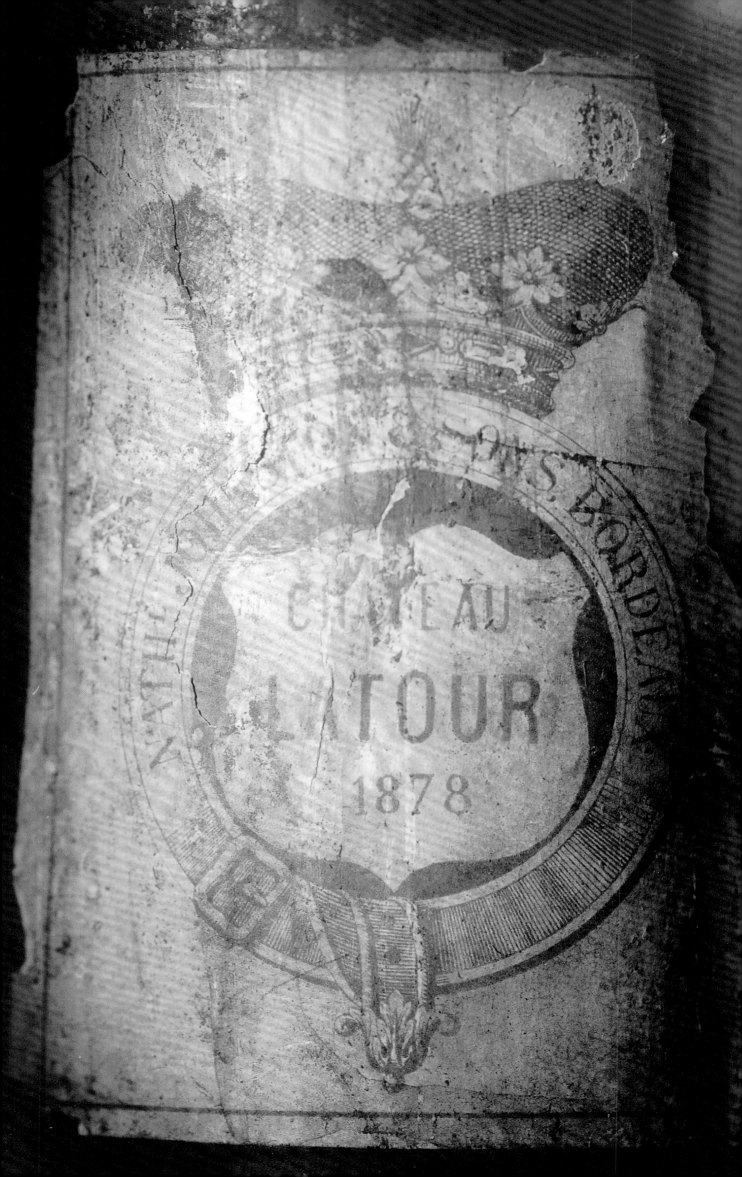

tant from the aristocrats and peasants of the old regime. For old-order labels, the nature of the wine was preordained.

The reinvented world of today's wine deals in more complex messages. Names are only names until they have a graphic context. The concept of the wine and the design of the label are as fresh as each other, and as original as the mind of the maker, which is what makes this book, and the fresh, witty, authoritative work of Jeffrey Caldewey and Chuck House, as much about wine as about their labels. The medium is the message.

DIALOGUE

The label is part symbol, part memory, and part storytelling.
The package personifies not only the wine, it has the
power to transform our own sense of identity.

—Jeffrey Caldewey

A successful wine package is a sculpture of the moment,
an authentic expression of time and place. At its best, it
transcends the past and the present with a vision
of the future that is uniquely its own.

—Chuck House

DESIGNING DESIRE

Message on a Bottle

Most people's lives are spent walking past things; mine is spent getting them to stop and take notice. A successful label beckons from a distance, then invites personal discovery the closer you get. Like revealing clues in a detective novel, the message on a bottle must engage the reader, skillfully maintain the suspense, and be compelling enough to lead you to the mystery inside.

The identity of a wine is revealed or concealed primarily through its package. Every day millions of bottles are acquired based solely on the desirability of their design. With other luxury goods the package simply complements the product, but with wine, the package provides the only sensory clues about what lies within. A wine's package design influences your buying decision, shapes your drinking experience, and is the only memento left at the end of the last glass. — JC

All the World's a Stage

Inherently theatrical, wine packages are entertainers that come alive in front of an audience. They arrive in costume, have their own fan clubs, and their 8 x 10-inch glossies comprise the bulk of this volume.

Sparking the dialog among the people at the table — dialog that enlivens noticeably, once the wine

22

arrives — wine evokes the evanescent quality of theatre. Maybe we designers are only stagehands, makeup artists, or set decorators, whose job it is to enable the winemaker to capture the audience's heart. But in a broader context, we are all acting in support of the genuine drama — playing nightly — that occurs amongst the people at the table who share the wine and food, and who deliver their lines without benefit of a script.

Whether it be a comedy, a drama, or perhaps a farce, everyday existence is heightened and dramatized by the presence of wine, which sets the stage for magic possibilities. The label is the overture, as well as the finale, and the human drama is richer for it. — CH

CREATION THEORY

Beginner's Mind

A successful design must defamiliarize the ordinary — deconstructing and reassembling design elements into a new language that is at the same time intrinsically familiar. To create distinction, a wine package projects individuality and meaning amidst a sea of similarity. Drawing on instinct, intuition, and improvisation, my challenge is to devise new combinations of symbols that will reveal the unique personality at the heart of the brand.

Each design is a process of chaos and creation — a chance for renewal. I approach every new project with a beginner's mind, full of wonder and curiosity, and devoid of preconceptions. With a child's enthusiasm, I stuff my pockets with rocks and twigs from the vineyard, make

notes on tabletops, and slip out of bed at midnight to scribble arcane doodles on scraps of paper. — JC

The Search for Clues

The way to understand and express the individual identity of a wine is to uncover the detail that contains the essence of a wine's character. Both the processes of making wine and making labels follow certain inevitable patterns, but the way in which a project deviates from that pattern offers the clue to its distinctive identity. At the heart of every problem lies the key to its own solution, and it is the search for that key that keeps the process authentic and alive.

Every few years, I re-read *The Adventures of Sherlock Holmes*, by Sir Arthur Conan Doyle, and I approach every project as a mystery I alone can solve. When I first arrive at a vineyard — ten miles away or ten thousand — I take scores of photos, make extensive notations, put soil samples in plastic bags, interview suspects — I mean subjects — and immerse myself completely in the experience. Without fail, it is the unexpected discovery that infuses the process with energy, enthusiasm, and joy. — CH

EGOS & ICONS

Character Study

Throughout history, art has primarily been a product of work commissioned by patrons. Michelangelo didn't commence painting the Sistine Chapel out of an irrational inner urge; he painted it because the Pope wanted

to bedazzle the masses, and had the purse to retain the best talent to carry it off.

As patrons go, vintners are among the most visionary and passionate. Each vintage brings renewed possibilities in the quest for the ideal. My challenge is to translate my client's vision of who they are, where they belong in the world, and what they are trying to achieve, into a philosophical expression, a visual narrative. In an extraordinarily personal process, I act as a medium between the inner life of my clients, and the inner life of the people who drink their wine. — JC

Passion / Play

My only plan when I begin a project is to acknowledge my own ignorance, and to utilize that as a strength. I try to look at things as they are, without preconceptions.

In my mind, there is no such thing as a customer. We are all individuals in search of meaning in our daily lives—meaning in what we eat, what we drink, and what we wear. My goal is to change people's lives for the better because of what I've created. I want to provide both the client and wine enthusiast with something that exceeds their expectations, something that suggests new possibilities.

With each project, I try to express the significance of what we—client, winemaker, designer, printer, distributor, retailer, consumer—are creating together. One of the keys to successful marketing is the ability to infuse people with the energy of their own product. When I

interpret the client's vision—unlock the project's unique personality, and express the client's genuine passion—I am helping to manifest a dream. — CH

TRANSFORMATION

Alchemy

Transformation describes what I do as an artist. Like the alchemist's metaphoric transformation of lead into gold, I translate my client's intangible ideas and dreams into tangible three-dimensional objects.

The transformation of concepts into reality requires not only creative talent and intellectual acumen, but rather daunting technical expertise. An intensely complex process, state-of-the-art wine labels represent the highest level of printing being done anywhere. Every single thing you can do to a piece of paper we are doing—four-, six-, and eight-color printing; embossing; foil stamping; spot varnishing; and die cutting. Some labels are actually printed from steel plates engraved by the same craftsmen engraving banknotes. The mechanical preparation and printing of a 3 x 4-inch piece of paper often takes several people working for months to achieve perfection. — JC

Architexture

The visual and tactile elements of a successful wine package are subordinate to its structural integrity. Forging a link between the graphic surface and the sculptural foundation is the essence of the package

designer's art. It is the crucial connection between art and artifact, between contemporary culture and archetypal myth.

Sophisticated tools will subvert the design process if called into action too soon. Often working with only paper, scissors, tape, and a bottle in front of me in my lap, I lay the conceptual foundation, and construct the graphic framework before I consider how to decorate the façade.

Designing wine packages is simultaneously a methodical craft and an extemporaneous art. The label's limited surface is a circumscribed universe, but within that universe the possibilities are infinite. Avoiding routine, formulas, and the impossible quest for perfection, I try to let the forces of nature unite in my work to express an energy that transcends my own limited artistic and imaginative abilities. — CH

ART & ARTIFACT

Cultural Artifacts

I've always been fascinated by the artifacts of ancient cultures. I am intrigued by the idea that wine developed simultaneously with civilization, and is itself a great indicator of the level of culture. Wine has always served a ceremonial, as well as a culinary function. Perhaps it is this ritualized consumption and its ability to alter consciousness that has made wine such a powerful talisman, and the wine label, something akin to an icon.

As collectible pieces of art, labels can demand prices far exceeding the value of the original wine. Personally, I derive great satisfaction imagining future archaeologists unearthing some of my designs affixed to bottle shards and displaying them in an exhibit on artifacts of the second millennium. — JC

Time Capsules

The wine package is best understood as an experience in four dimensions: a two-dimensional example of graphic, commercial, and fine art; a three-dimensional sculpture; and a theatrical event that unfolds as a process

through time. A multidimensional experience involving all the senses, it is the time spent in the company of friends that makes the wine label unique.

Wine has the ability to put us in touch with a deeper sense of our own identity, and a richer understanding of our human nature. Our impulse toward ritual is deeply rooted, and the wine package is a powerful evocation of this characteristic. It is a sculpture of the moment, a genuine reflection of its time. The wine, the vineyards, the evenings of laughter and light, are all part of our human heritage, and this sense of community imbues what I do with meaning, depth, and joy. — CH

PERSISTENCE OF MEMORY

*All intelligent thoughts have
already been thought, what is necessary
is only to think them again.*

— Johann Wolfgang von Goethe

CHATEAU MONTELENA
Napa Valley, California

This cut stone edifice is one of Napa Valley's historic structures. Now a venerable icon of California collectors, the Chateau Montelena label was a collaboration with illustrator Sebastian Titus based on an original composition from the Vintage Image book series in the earliest days of the California wine renaissance. The timeless, monochromatic pen-and-ink label has remained unchanged for a quarter century.

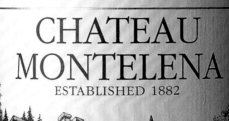

CHATEAU MONTELENA

ESTABLISHED 1882

Cabernet Sauvignon

NAPA VALLEY

1998

GROWN, PRODUCED & ESTATE BOTTLED BY
CHATEAU MONTELENA WINERY, CALISTOGA, CALIFORNIA
ALCOHOL 13.9% BY VOLUME

EL MOLINO

Napa Valley, California

The old mill pictured on the El Molino label was already a historical monument when the brand was first introduced in 1872. Based on the original antique stone lithograph, limited design input was needed to resurrect the label, which had been dormant since the winery's untimely closing during Prohibition. In an age of constantly morphing identities, it is refreshing to see a label with more than a century of continuity.

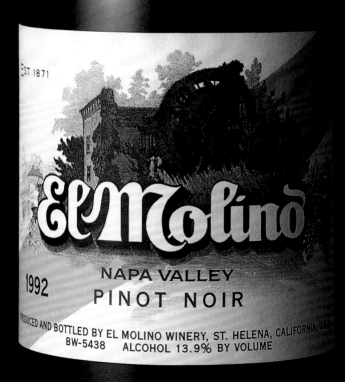

FESS PARKER
Santa Ynez Valley, California

Renowned for his film roles portraying American folk heroes, founder Fess Parker creates an equally mythical wine. Seeking to relate his cinematic roles with the wine's traditional European roots led to an epic quest in many backstreet antiquarian booksellers, searching for clues on the rise and mythology of folk heroes from the 1800s. Ultimately, the fine, leather-bound antique books themselves inspired the label's design. Custom-mixed inks combined with sculpture embossing create a kidskin-like patina, which is edged in gold leaf. Hand-lettered script conveys a signature impression, while a coonskin cap is treated as an heraldic crest.

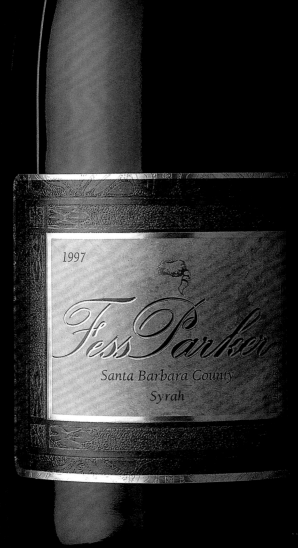

GUNDLACH BUNDSCHU
"VINTAGE RESERVE"
Sonoma Valley, California

Each year, Gundlach Bundschu Winery produces a Vintage Reserve, limited-edition bottling of their finest Cabernet Sauvignon. The "Founding Fathers" label was designed to honor the early American pioneers who recognized the potential of the fledgling American wine industry. Rendered in the style of heroic American primitivism, the champions of American wine — Franklin, Jefferson, Roosevelt, Grant, and Carroll, along with Jacob Gundlach and Joseph Bundschu — are seen socializing in Heaven, which just happens to look like the Sonoma Rhinefarm, circa 1858.

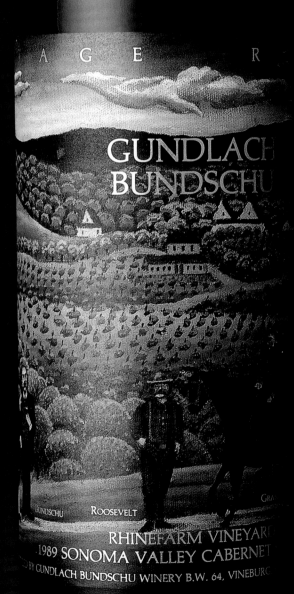

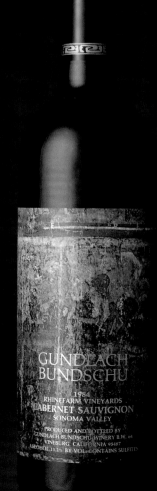

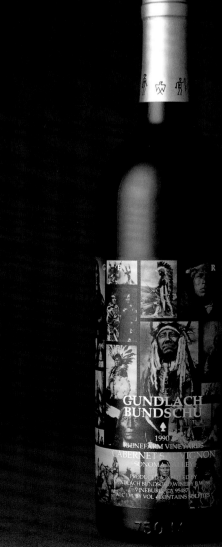

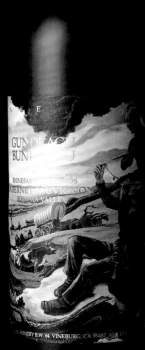

LEWELLING

Napa Valley, California

One of the most prominent California pioneers, George Lewelling's landmark Napa Valley vineyard was originally planted in 1864 and remarkably, is still owned and operated by his direct descendants. With a rarified pedigree like that, one naturally turns to the historical record for design clues. Finding the actual calling card of the patriarch amidst the family archives was a revelation. Very few embellishments were required to transform this personal announcement into a family emblem.

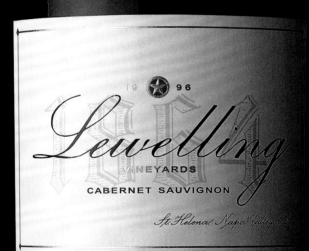

NAPA REDWOODS ESTATE
Napa Valley, California

One of Napa's historic ghost wineries revitalized, the Napa Redwoods Estate label captures the essence of the period — branding luxury the way they did in the 19th century. Reproducing the label as an engraving gives the vellum stock a subtle texture that intensifies the ink saturation and results in a rich, dense color. The eye-arresting red monogram is done in an old-world style and contains the letters NRWE. Both the heavy antique claret bottle and monogrammed capsule carry through the atavistic theme.

NAPA REDWOODS ESTATE

19 99

MOUNT VEEDER

NAPA VALLEY MERLOT

CASTLE ROCK VINEYARD

OLD TELEGRAM

Santa Cruz, California

Old Telegram, another fine product from Bonny Doon Vineyard, pays homage to the Rhone classic Vieux Telegraphe in its style of viticulture, as well as its name. The label's graphic style takes the title quite literally. Faux antique, embossed paper strips replicate a missive sending urgent news of vinous enlightenment. Its name is spelled out in blind-embossed Morse code below the title. The original label was proposed to be in an actual envelope on the bottle, which would have to be purchased before it could be read. Only the violation of certain technical requirements, marketing considerations, legal restrictions, and fundamental laws of logic prevented this solution from being implemented.

OLD TELEGRAM

FROM BONNY DOON VINEYARD

RE 1998 CALIFORNIA MATARO (MOURVEDRE)

GRAPE OF COTE DE PROVENCE AND SOUTHERN RHONE

IN AMERICAS AND ESPANA ALSO CALLED MATARO STOP

PEPPERY MEATY WILDLY AROMATIC CHARACTER STOP

FLAVORFUL FOODS STOP WHEN SEE ON SHELF OR

THIS CORRESPONDENT WOULD WRITE MORE STRAIGH

COPY BUT SUFFERS FROM ADVANCED ETIQUETTORI

PRODUCED & BOTTLED BY BONNY DOON V
SANTA CRUZ, CA USA • ALCOHOL 14.5%

ORNELLAIA
Bolgheri, Italy

Descendants of a winemaking dynasty, the proprietor's family has been producing world-class wines in Italy since 1385. As one of the first people to plant vineyards west of Tuscany's customary growing region, the challenge was to carry over a legacy of place and tradition to a new winery in a new location. The use of classic design vocabulary emotionally places the wine among the world's best, but the wine itself silences the arguments of those who advocate tradition for tradition's sake.

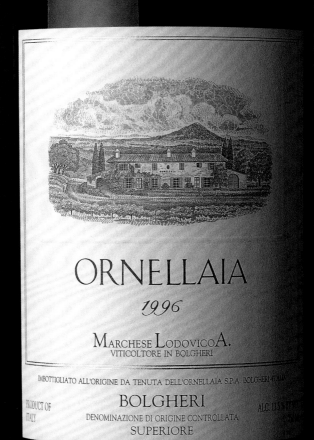

SPOTTSWOODE

Napa Valley, California

In the tradition of an Ansel Adams photograph, the Spottswoode label incorporates a full range of tonal values without the obvious use of color. The brightest hue is the cream-colored paper itself, overprinted with a slightly darker linen texture. The pen-and-ink illustration supplies the middle tones, while the glossy black bottle and Victorian typeface, pruned of its elaborate flourishes, supply the darkest tone—one hundred percent black. Gold foil provides a touch of glamour, but only when the wine is poured does rich, saturated color become part of the presentation.

SPOTTSWOODE

1998
CABERNET SAUVIGNON
Napa Valley

GROWN & CELLARED IN ST. HELENA, CA • BOTTLED IN RUTHERFORD, CA
BY SPOTTSWOODE VINEYARD & WINERY • ALC. 13.5% BY VOL • USA

STAGS' LEAP
Napa Valley, California

Based upon an antique Stags' Leap label from the 1890s, the revised design remains true to its heritage. All pretense is stripped away. No borders confuse the issue. The label is nothing more than black ink on a relatively insignificant piece of white paper, yet it resonates luxury. The illustration, inspired by wood engravings common to the period, adds an important kinetic element to the composition. The stark black-and-white theme extends even to the capsule, though closer inspection reveals a subtle tone-on-tone pattern in the texture.

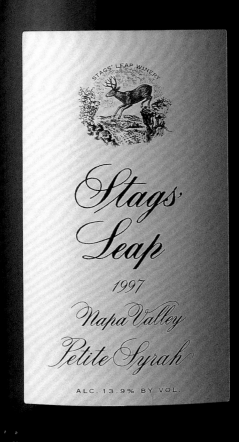

VACHE

Cienega Valley, California

The historical record is the basis for this narrative design. Theophile Vache, patriarch of the brand, was among the early Europeans who settled in California. Planting vineyards in the Cienega Valley in 1850, Vache takes his place among a handful of viticultural forefathers. The label, designed to read like an antiquarian manuscript or a weathered bill of lading, was penned by hand and emblazoned with the Vache family herald — a rampant bull.

VACHE

CABERNET SAUVIGNON

Viticulture in Cienega Valley traces it's roots
to pioneer Theophile Vache who first planted grape
vines in this historic valley in the year 1850

2000 Estate Grown Produced & Bottled

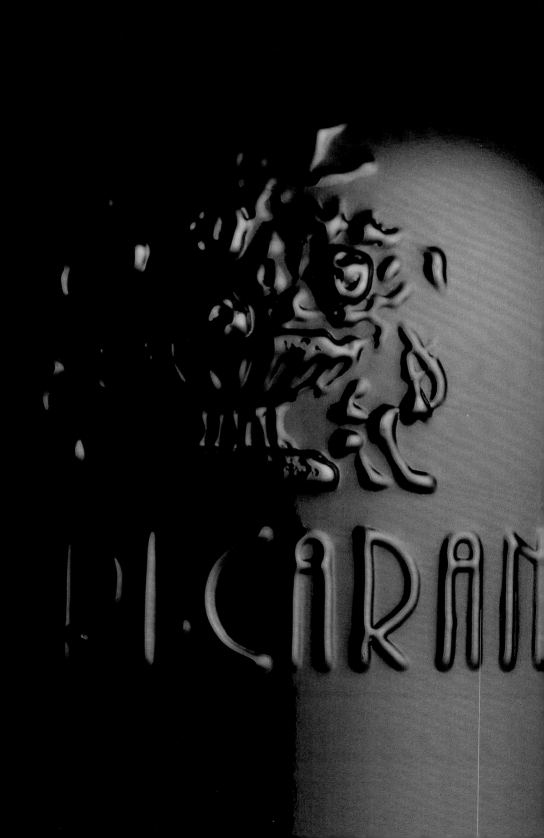

THROUGH THE LOOKING GLASS

*Mirrors should reflect a little
before throwing back images.*

— Jean Cocteau

ARBIOS

Alexander Valley, California

The juxtaposition of a bold woodblock stamp with the refined symmetry of a classic Roman typeface stands as a perfect metaphor for the winemaker's art: the woodblock symbolizes the grapevine and its earthy origins; the gold type represents man's civilizing influence on the natural order. Both crimson red ceramic and 14-karat gold are kiln-fired directly on the glass, rendering the use of paper unnecessary. The matching stripe on the capsule adds a finishing flourish.

ARBIOS

ALEXANDER
VALLEY 1993
CABERNET
SAUVIGNON

FERRARI-CARANO "TRÉSOR"
Dry Creek Valley, California

Italian for treasure, Trésor honors the Italian heritage of the wine's proprietor. The bottle glass itself is molded in Italy and embossed with a family icon. The oil painting by Italian artist Marco Sassone was commissioned to reflect the depth, complexity, and richness of the wine. The color palette of cardinal, crimson, and magenta creates a striking presence on the bottle, as well as in your glass. The designer's function in this instance was allowing the art to make the primary statement by restricting typography to a merely archival purpose.

FERRARI · C

1995

TRÉSOR

FERRARI-CARAN

RESERVE

SONOMA COUNTY RED TABLE W

HONIG VINEYARDS & WINERY
Napa Valley, California

Honig wines spend their life in the bottle nestled in a replica of the vineyard in which they were born. The front label illustrates the eastern hills of the Napa Valley, while the Rutherford estate vineyard and the Mayacamas Mountains beyond frame the wine from behind. Resembling a trompe l'oeil fresco, the golden light that filters through the Sauvignon Blanc evokes the sunlight in which the grapes basked during their time on the vine.

RESERVE

2000

HONIG

NAPA VALLEY

SAUVIGNON BLANC

RUTHERFORD

ALC. 13%

RESERVE RESERVE RESERVE

LYETH

Alexander Valley, California

Rather revolutionary for its time, the Lyeth package has become a classic of wine design. It was the first to use applied ceramic lithography, where ink infused with 18-karat gold particles is silkscreened on the glass bottle, then fired in a 1200-degree kiln. Ground-breaking on another frontier, the package was the first proprietary wine in California to state nothing more than the brand, logo, and vintage date, with varietal breakdowns revealed only on a diminutive back label.

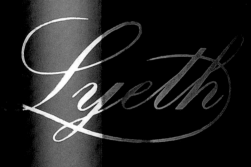

1 9 9 3

MARIAH

Mendocino County, California

High atop a ridge in Mendocino County, the grapes
for Mariah contend with an almost constant wind as
they struggle to survive. The only California appella-
tion to be based on elevation, anyone who has made the
arduous journey to the hilltop vineyard will recognize
the golden glow of the sun setting against the black sil-
houette of the mountain. A torn-paper stencil, copper
spray paint, and the height of the bottle itself created
a three-dimensional quality, and a sense that the whole
illustration was made of air. Swirling script typography
echoes the theme of nature "Glowing in the Wind."

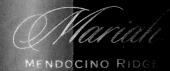

Mariah

MENDOCINO RIDGE

ZINFANDEL

1997

OUTPOST
Napa Valley, California

A Zinfandel vineyard on Howell Mountain with a commanding view overlooking the Napa Valley: snow, sleet, wind, and rain combine to make this truly an outpost of horticultural civilization. The large script *O* and gothic bank type — both type fonts greater than a century old — combine with a black and silver motif to give the wine an unexpectedly futuristic character: the feeling that it is both an Outpost of the galaxy as well as the vineyard.

OUTPOST

HOWELL MOUNTAIN
ZINFANDEL
1998

PACIFIC RIM

Santa Cruz, California

Whether the message is about history or sense of place, style, or a level of craftsmanship, a wine's label and packaging are the winemaker's only means of communicating his intent. For Bonny Doon's Pacific Rim Riesling that meant associating the German varietal with Pan-Asian cuisine. A playful game of illusion, the label evolved over dinner in a Japanese restaurant with a menu, a bottle, and a pair of borrowed scissors. Floating on a half-shell, a romantic figure reads in German a critique of pure Riesling, while the subject of her dream revolves around her—an aquarium of sushi floating in a golden sea.

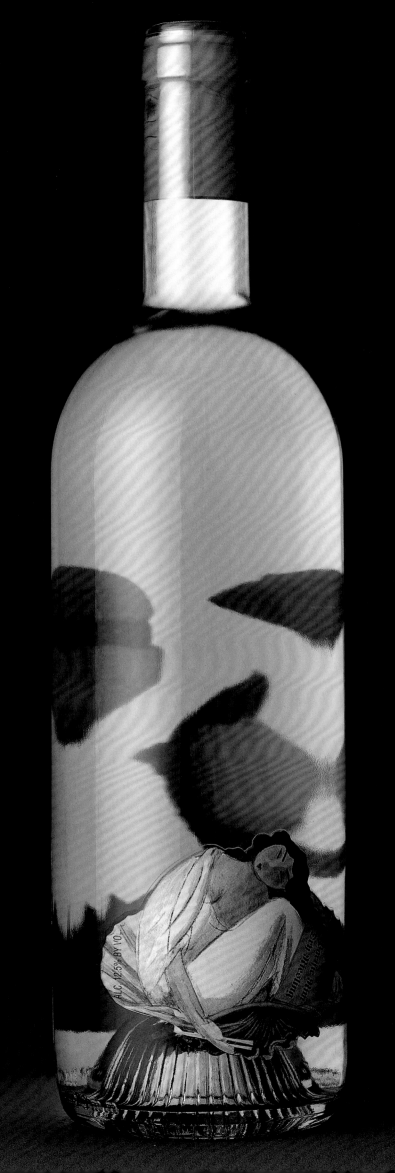

VICHON

Napa Valley, California

A right-angle, and the suggestion of a contoured hill-side define the label's visual field. Abstract art interprets the individual spirit of each Vichon varietal: in color, technique, and even the medium itself. Chardonnay, for example, incorporates vanilla, melon, and citrus juices into the artwork, while the silky texture of the Merlot and its flavors of ripe cherry and berries were evoked with actual fruits and juices applied to silk fabric. The emotional impact of the color is balanced by a more cerebral approach to the typography.

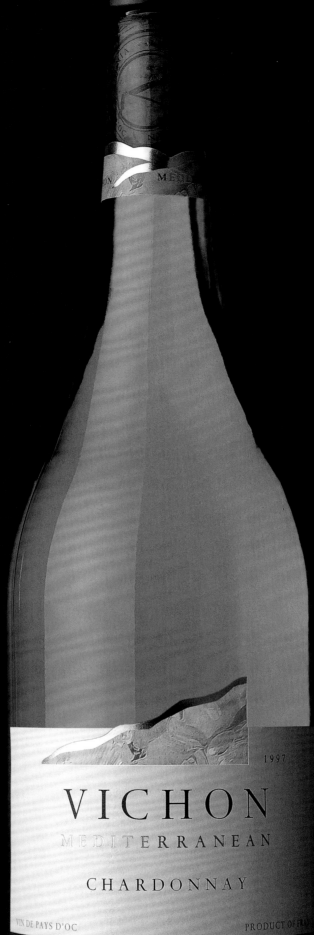

VICHON

MEDITERRANEAN

CHARDONNAY

1997

VIN DE PAYS D'OC PRODUCT OF FRANCE

A ROBERT MONDAVI FAMILY WINE

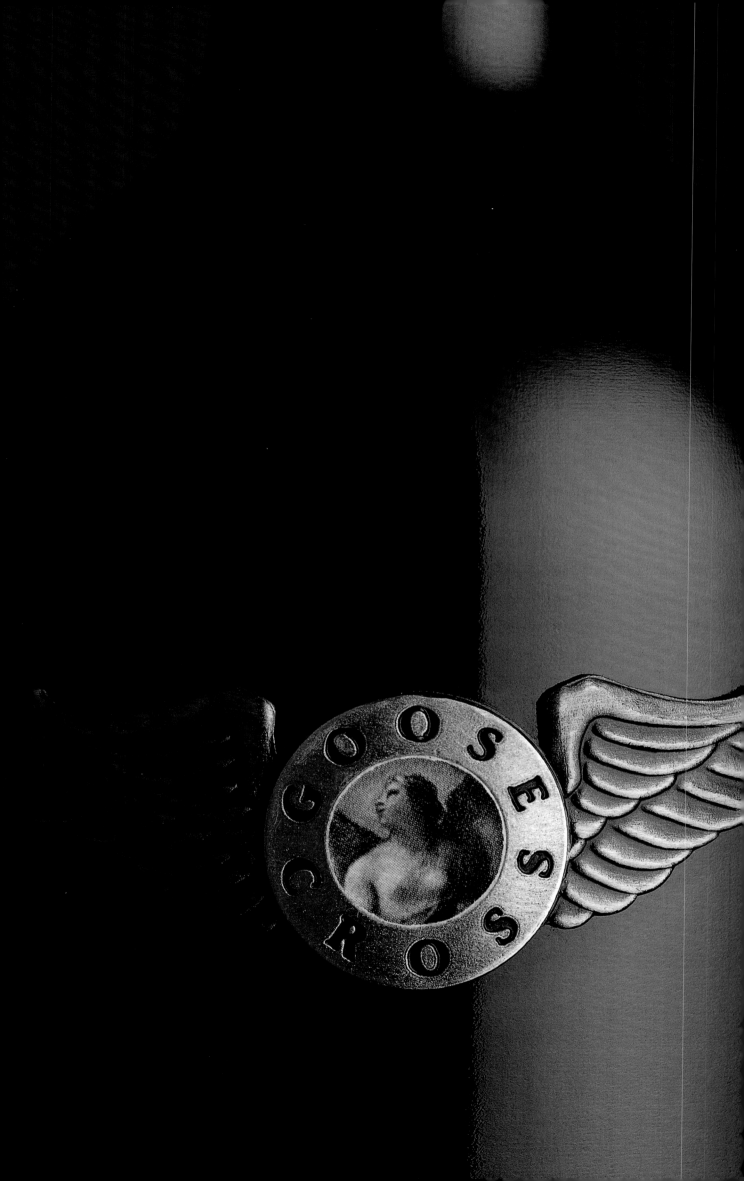

KIND OF BLUE

Without the roots, there ain't no fruits.

— Willie Dixon

AEROS
Napa Valley, California

The challenge to create a sensual interpretation of a motif based on a flying goose for Goosecross Cellars' artist tier was no small task. Choosing Aeros as the theme—the semantic interweaving of the terms for flight and love—the label is actually a three-dimensional sculpture forged from bronze and nickel, then bonded to the glass surface. At its center, winged goddess Psyche, once seduced by Cupid, symbolizes both sensual desire and intellectual pursuit.

B.R. COHN "PLATINUM"

Sonoma Valley, California

In a fusion of nature and art, the Platinum label illustrates the beauty of the land and the spirit of the proprietor. Emblematic of the olive trees present on the Sonoma Valley vineyard, the image of an olive branch was geometrically altered and inlayed with Japanese paper to resemble a distinctive piece of art deco jewelry — or, when held to the light, a beautiful piece of stained glass. Evoking the elegance and exuberance of a sparkling wine at its effervescent best, the juxtaposition of matte black and shiny foil infuse the package with life.

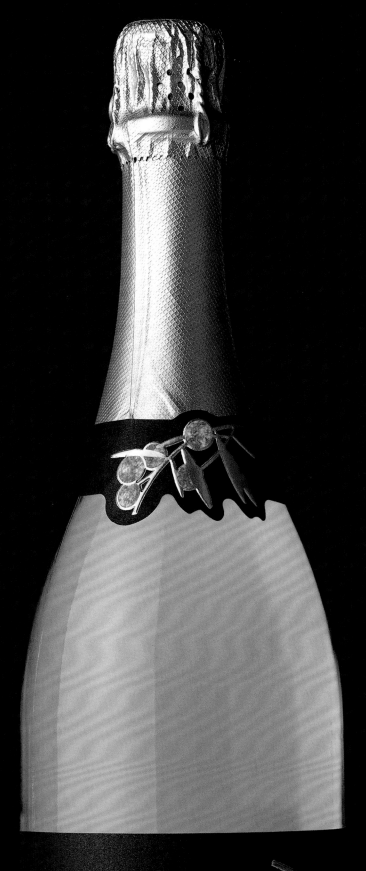

PLATINUM
1985 SONOMA VALLEY SPARKLING WINE

VINTED & BOTTLED BY B.R. COHN
GLEN ELLEN, CALIFORNIA
CONTAINS SULFITES • 750 ML
ALCOHOL 12.0% BY VOL

BELLA VIGNA
Lodi, California

A breathtakingly beautiful vineyard, even the name
Bella Vigna demanded a painterly interpretation of
the winemaker's vision. Because vineyards are notori-
ously difficult to illustrate with any distinction, a
Polaroid dye transfer was chosen as the basic medium.
The print was then overdrawn in pastel in an effort to
capture the soul of the site and imbue the finished
composition with an impressionist flair.

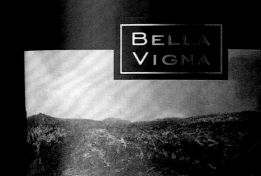

BELLA
VIGNA

1997 • MERLOT • LO

Twin Creeks Vineyard

BLUE ROCK
Alexander Valley, California

Sometimes details are extraneous: The brand is everything you need to know. Exuding confidence, Blue Rock is a statement in minimalism, a reflection of cosmopolitan opulence. The conceptual context is reduced to a meditation on the color blue— not just any blue— but a specific and proprietary iridescent blue found only here. The source of this fascination with blue is derived from the ribbons of serpentine strata running deep below the surface of the vintner's Alexander Valley vineyard. The horizontal blue strip of a label, and its reflection in the capsule, are the leading identity cues, with typography playing only a supporting role.

BLUE ✳ ROC

LE CANARD FROID

Santa Cruz, California

Le Canard Froid — "The Cool Duck" — was an experiment, perhaps more successful graphically than viticulturally. "What if Cold Duck were cool?" A duck peering existentially into the bell of a saxophone echoes the indisputably cool iconography of the Blue Note jazz album covers from the 1950s and 1960s. The label proclaims the artist: Le Canard; and his magnum opus: Froid. Although a one-time-only product, the legend lives on posthumously in that great jazz tradition. Only the good die young.

EL FELINO

Mendoza, Argentina

El Felino is part of a menagerie of wines called Nativo Argentine. Inspired by indigenous pottery and decorative elements from early Argentine cultures, the name and design were created as an expression of the authentic South American terroir. The color palette for the series reflects the natural colors of the Andes, while the use of contemporary typography and open space creates the look and feel of a gallery exhibition poster. Understanding that nothing is more modern than indigenous art, the rough, unsophisticated cat paired with the clean layout presents a playful, imaginative character, reflecting the character of the wine itself.

2000

El Felino

MALBEC
Mendoza

Product of Argentina

ALC. 13.5% BY VOL.

PEPPERWOOD GROVE

Napa, California

Conceived as a shopping experience, the whole persona of the Pepperwood Grove package rests on its ability to tell a story on the shelf of a supermarket. The white strip of paper with its shiny blue box riveted off center, creates a dissonance at first glance that attracts your attention. Designed to be viewed as a collection, the verticality of the white paper when lined up on the shelf produces the effect of a picket fence, maximizing the impact of a store display.

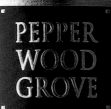

PEPPER
WOOD
GROVE

CABERNET

FRANC

CALIFORNIA

1999

POGGIO ALLE GAZZE

Bolgheri, Italy

The proprietor named this fine Tuscan white wine Poggio Alle Gazze, meaning "Hill of the Magpies," to commemorate the airborne thieves that raid his vineyards and olive groves. The label employs balanced typography and a formal gold frame to create a traditional structure, then counteracts the classicism with playful imagery and an unexpected illustration style that is sympathetic to the subject, without condoning his less-than-exemplary behavior.

Poggio alle Gazze

Marchese Lodovico A. viticoltore in Bolgheri

1998

SAUVIGNON BLANC

Toscana
Indicazione Geografica Tipica

Imbottigliato da Tenuta dell'Ornellaia s.p.a. Bolgheri - Italia

750 ml - ALC. 12.5% BY VOL. - PRODUCT OF ITALY - WHITE WINE

RUSACK

Santa Ynez Valley, California

Shortly after purchasing the island of Santa Catalina in 1919, family patriarch William Wrigley Jr. began construction of the Catalina Tile Company. Although tiles of every sort were created, it is for the decorative paving tiles that the island became best known. Noted for their brilliant hues and distinctive glazes, these early ceramic designs remain highly prized by collectors. Today, several generations later, the family ethos of craftsmanship is directed toward the creation of wines in the Santa Ynez Valley. Appropriately, an original paving tile was chosen as the symbolic representation of the family estate.

RUSACK

Santa Ynez Valley

PINOT NOIR

2002

SIGNORELLO

Napa Valley, California

The Signorello label pays tribute to the vintner's Italian lineage. A sculpture-embossed reproduction of Michelangelo's Bacchus appears here as a bas-relief portrait, foiled in gold, and joyously radiant. The circular format of the logo references the imperial coin of the realm, while the stonelike texture of the paper and the classic Roman typography inscribed on the edifice lend the composition a monumental dimension.

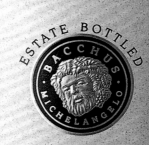

ESTATE BOTTLED
·BACCHUS·
·MICHELANGELO·

SIGNORELLO

1999 NAPA VALLEY SYRAH

UNFILTERED

ALC. 13.9% BY VOLUME

LE CIGARE VOLANT

Santa Cruz, California

Designed to operate on dual levels, Le Cigare Volant is at once serious and subversive. Inspired by an obscure 1950s ordinance in France's Chateauneuf-du-Pape region forbidding the landing of flying "cigars" within the provincial boundaries, the label's first impression relates the wine to the Chateau region and its prestigious heritage. Closer examination, however, reveals a Victorian spaceship beaming up a peasant and his cart. A benchmark design, Le Cigare Volant was the first wine package to include the playful addition of a cigar neckband — a detail that has spawned a generation of flattering imitators.

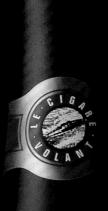

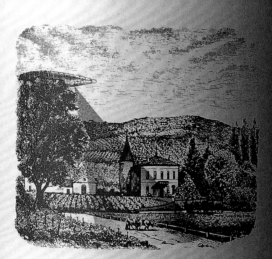

LE CIGARE VOLANT

RED WINE

CALIFORNIA

ALCOHOL 14.5% BY VOLUME
PRODUCED AND BOTTLED BY BONNY DOON VINEYARD
SANTA CRUZ, CA • U.S.A. • EARTH

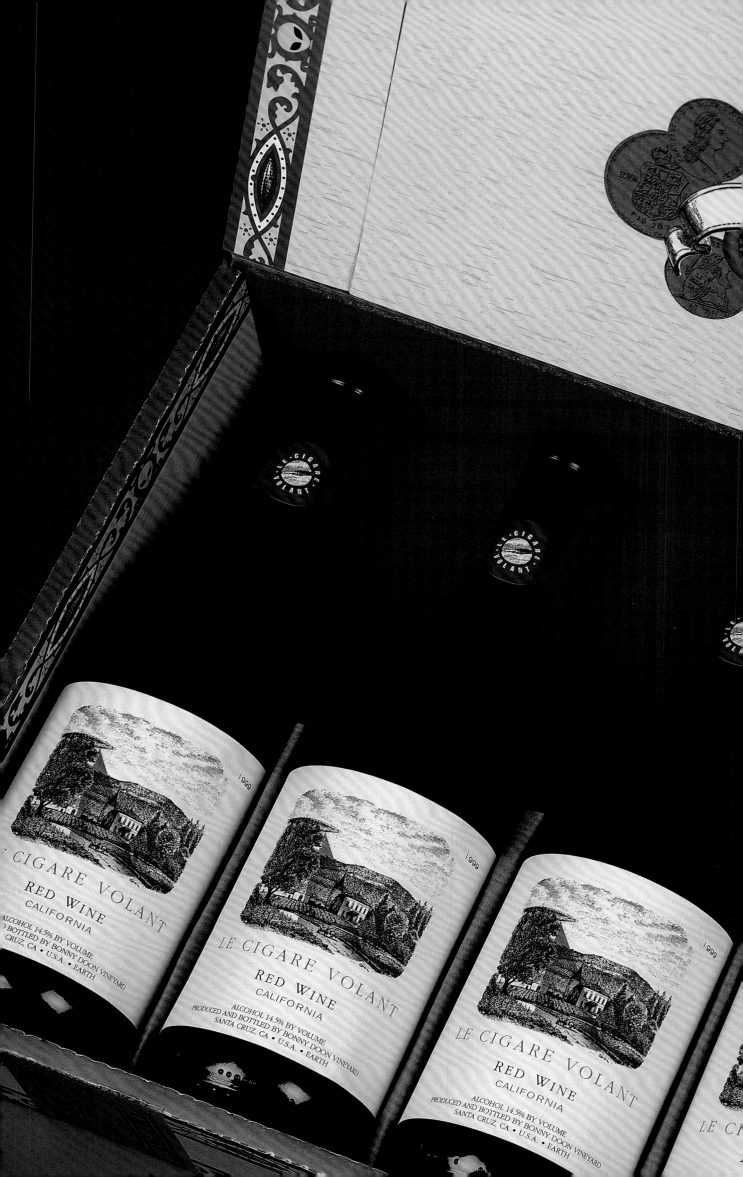

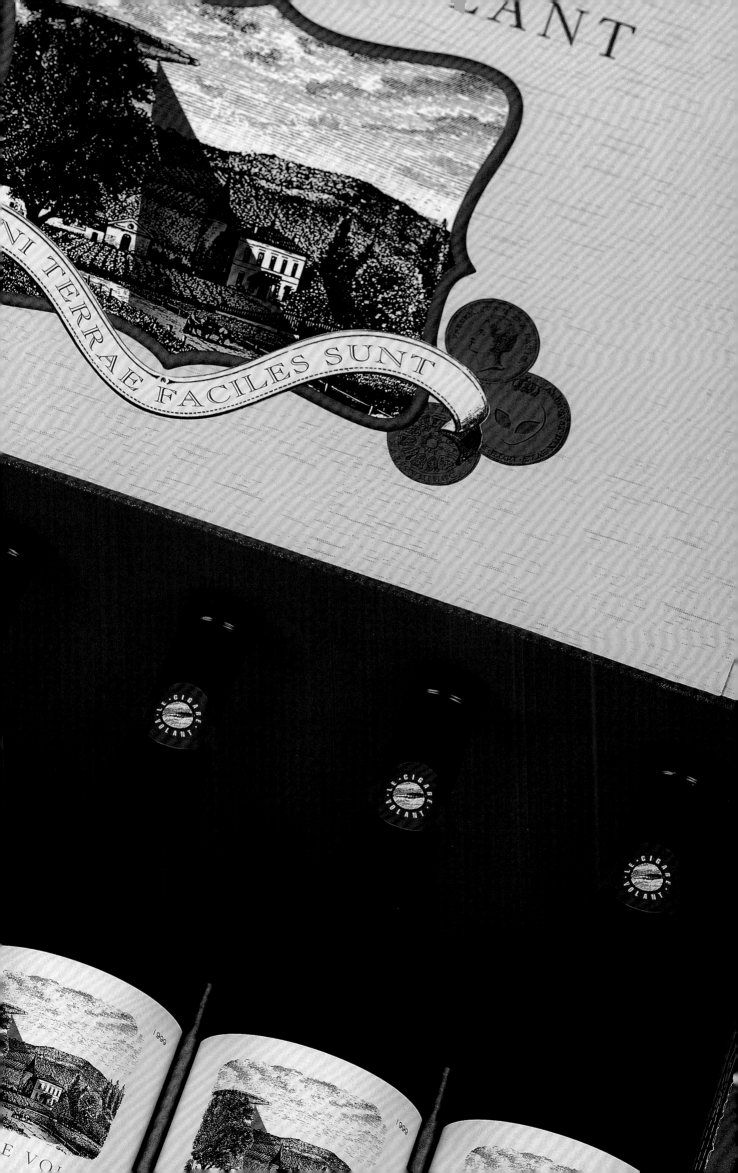

GAINEY

Santa Ynez Valley, California

For generations the proprietor's family has tilled the fertile soil of Santa Ynez Valley. This very personal relationship to the land is emulated in the label by replicating the color and feel of the soil, along with the textures of the trees and leaves. Actual leaves and earth were used to create the composition, utilizing a natural organic color palette literally carved from the earth. Vertical and horizontal elements intersect, lending balance to the otherwise asymmetric format. The Gainey insignia lends its imprimatur in the form of a blind embossing.

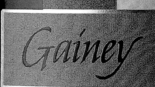

MARCASSIN

Sonoma Coast, California

Occasionally the designer finds himself an unnecessary third party in a relationship that, in this case, is clearly going hog-wild. Drawing from Greek mythology, the legendary enchantress Circe becomes the metaphor for wine's transformative powers. Renowned for her bewitching spells that change men into animals, the goddess is depicted here changing a Roman centurion into a bull with the magic power of wine. Both the idea and illustration came from the winemaker, as the designer all but excused himself from the equation.

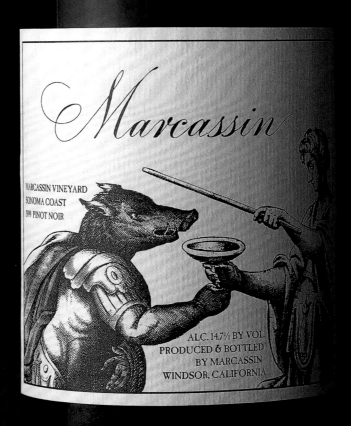

PACIFIC ECHO
Mendocino County, California

The Pacific Echo project was commissioned by the venerable French luxury firm of LVMH. Charged with creating an entirely unique and contemporary look for the brand, old-world decorum and Champagne-style traditions were eschewed in favor of a California ethos. Freeform and kinetic like its namesake the Pacific Ocean, the label's textural background — achieved by the artist's liberal use of finger paint and local Mendocino herbs — reflects the undulating ocean currents.

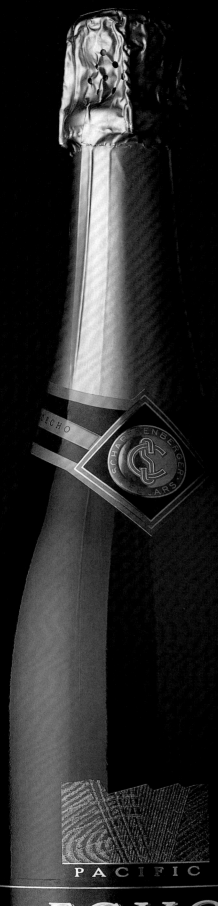

PACIFIC

ECHO

BLANC DE BLANCS
1995
ANDERSON VALLEY
SPARKLING WINE

100% CHARDONNAY

SELENE

Napa Valley, California

The Selene label pays homage to the seasons, whose vagaries shape our destiny. Fashioned from a Japanese playing card presented by the winemaker, the dense textures and rich colors—mustard, burgundy, and rock—represent the intensity of the wine, while the mythic moon imagery and name engender a softness. The rough, hand-drawn edges convey the personal energy behind the project, its handcrafted nature more human spirit than technical precision.

SAUVIGNON
BLANC

CARNEROS

1999

HYDE
VINEYARDS

SELENE

ALC. 13.0% BY VOL.

TURLEY

Napa Valley, California

Symbolic representations of the four elements, which combine to make possible the winemaker's magic, infuse this variation on the Turley theme. Moon, sun, and stars represent the members of the family and the power of the universe. Primary colors highlight symbolic representation of the four elements in each corner of the image. Gold metallic foil gives an additional expression to the alchemical concept. Hand-dipped with a sunny yellow wax, the package as a whole is both earthly and divine.

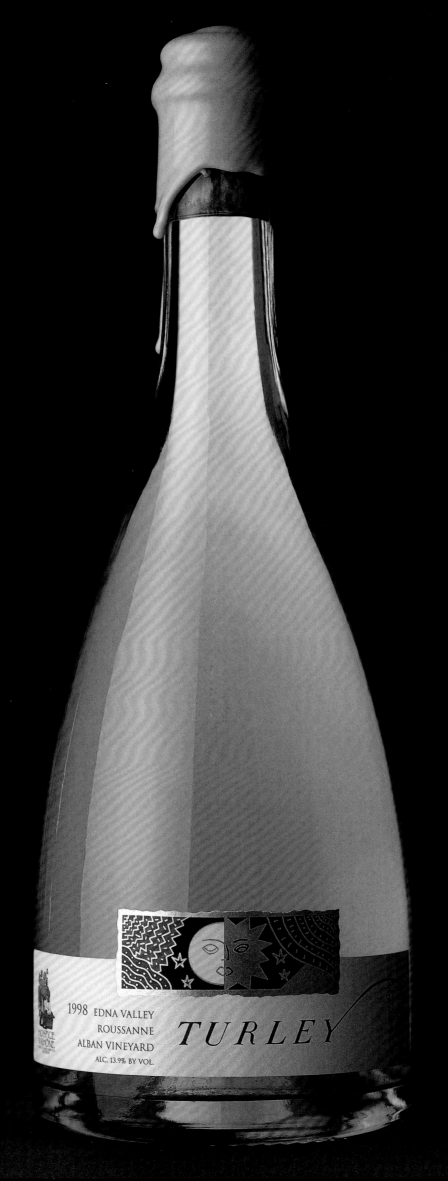

VERAISON

Napa Valley, California

Veraison is the viticulture term referring to the adolescent life of a vine when the berries mature into grapes and display their dramatic color metamorphosis from green to purple. It is an exhilarating time for the grower—his children have matriculated. This color scheme serendipitously also relates to the designer's palette as a juxtaposition of opposites. In that time-tested device for gauging color compatibility, green and purple appear on opposite ends of the color wheel. With art, as in real life, opposites often attract.

VERAISO

19 🍇 99
NAPA VALLEY
CABERNET
SAUVIGNON

87% KRUPP VINEYARD/13% STAGEC

WHITEHALL LANE

Napa Valley, California

The avant-garde abstract expressionist responsible for this label was the designer's daughter, age three. Her medium: melted wax crayon. A father-daughter date at preschool led to the discovery of what served for fifteen years as the emblem for Whitehall Lane's finest Cabernet Reserve. When the winery decided to adopt a smaller, updated version in 1996, the artist was asked if she would allow her work to be turned on its side to accommodate the new format. Her answer? "Actually, that's the way I meant it to be: It's been on its side all along."

Whitehall
LANE

1988
RESERVE CABERNET SAUVIGNON
Napa Valley

PRODUCED AND BOTTLED BY WHITEHALL LANE WINERY
ST. HELENA, NAPA VALLEY, CALIFORNIA BW 4974 • ALCOHOL 13.5% BY VOL • CONT

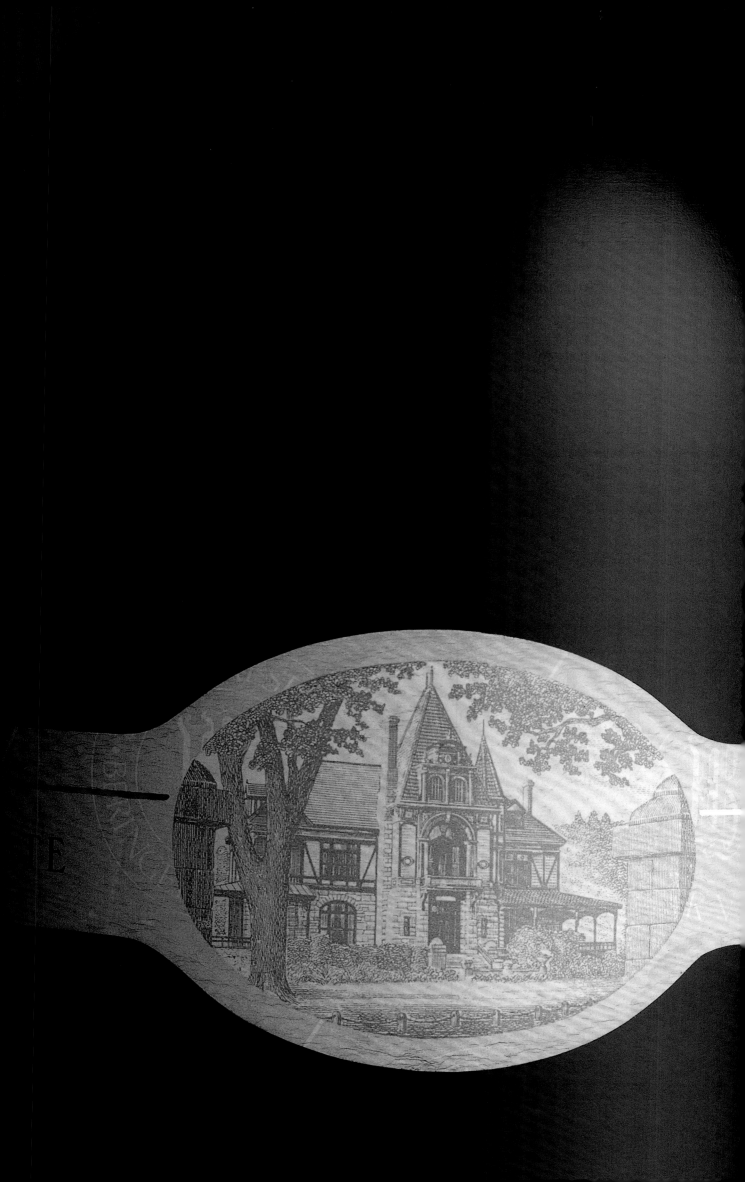

SENSE & SENSIBILITY

The moment one gives
close attention to anything,
even a blade of grass,
it becomes a mysterious,
awesome, indescribably
magnificent world in itself.

— Henry Miller

ARAUJO
Napa Valley, California

Recognized as one of California's most renowned sources of Cabernet Sauvignon, an oversized label and European-style engraving pay homage to the Eisele Vineyard's world-class prestige. The label's dusty earth color suggests its terroir, and attests to the wine's impressive cellaring potential. A sculptured red Cabernet leaf, embossed and foil stamped into a wax seal, provides the only accent to the classic engraving of the Calistoga vineyard, Palisades towering above.

ESTATE **1993** BOTTLED

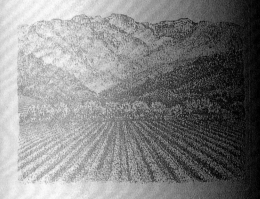

EISELE VINEYARD
NAPA VALLEY

Cabernet Sauvignon

ARAUJO
ESTATE WINES

GROWN, PRODUCED AND BOTTLED
AT THE EISELE VINEYARD

BERINGER
Napa Valley, California

A Napa Valley landmark dating back to the mid-19th century, the Beringer package design acts as a graphic bridge to the estate's ancestral past by linking a variety of classic visual cues into a composition that speaks of refinement and elegance. The original stone chateau is rendered in a steel engraving, which reflects respect for traditional technique. A watermark, European script, and cigar band also lend convincing historical resonance. In a novel approach, romance copy that is normally associated with the back label is instead positioned on the face.

120

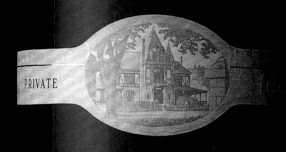

PRIVATE

Beringer.

1984

Napa Valley

Cabernet Sauvignon

This Private Reserve Cabernet Sauvignon
tribute to Winemaster Edward Sbragia's
in selecting only wine of outstanding qual
our vineyards for our Private Reserve
this wine Edward selected special
our Napa Valley vineyards for the
complementary varietal flavor and aging
Produced and bottled by Beringer Viney
Helena, Napa Valley, California.

ALCOHOL IS 13.3% BY VOLUME CONTAINS

BRYANT FAMILY VINEYARD
Napa Valley, California

For the Bryant Family Vineyard, the task of labeling one of the world's legendary wines relegates considerations of design to a secondary level of importance. Antique typography relates the wine to French winemaking tradition, while the gold ornamental divider and lipstick-red foil are its only concessions to glamour. Like a secure romantic relationship, the winemaker takes for granted that you will bring a refined sensibility to the experience, and refrains from effusively filling the space.

Proprietor Grown

1996

Bryant Family Vineyard

750 ML

CABERNET SAUVIGNON
NAPA VALLEY

DEVIL'S CANYON
Napa Valley, California

Devil's Canyon takes its name from its near mythical, though very real geographic location. High in the Mount Veeder range, a treacherous gorge, hewn by ancient volcanic eruptions, divides Napa and Sonoma Valleys. Amidst the abundant flora and fauna, a few dozen acres are carved from the ridge-top caldera. Reminiscent of a medieval contract, the quill-penned labels are singed by flames and affixed to bottles capped with crimson sealing wax, presenting a droll Faustian reference. From both the inkwell and the inky depths of the glass emerges one hell of a wine.

Devils Canyon
Cabernet Sauvignon
Napa Valley

Mt. Ve...

EDGEWOOD
Napa Valley, California

Steeped in history, the origins of the Edgewood Estate
stem from the very roots of Napa Valley winemaking.
With the turn of the illustrator's hand, the wood
engraving restores the 150-year-old stone winery to its
original pastoral setting. Sculpture embossing adds a
layered, textural dimension, and an ivory hue implies
antiquity, while gray pinstriping repeated on both label
and capsule gives the overall composition an air of
masculine dignity.

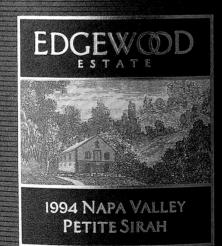

ST. HELENA

EDGEWOOD
ESTATE

1994 NAPA VALLEY
PETITE SIRAH

GROTH
Napa Valley, California

A lesson in understatement, Groth's generous use of
white space makes the selection of fine vellum as impor-
tant as what is printed upon it. The label reflects the
winery's grandeur and elegance, utilizing refined old-
world script and restrained border rule. The illustration,
engraved by hand at actual size on the same steel plate
from which each label is individually produced, depicts
the architecturally striking chateau surrounded by one
hundred acres of meticulously manicured vines.

JORDAN

Alexander Valley, California

Premier among new-world estate labels, Jordan is but one of a grand succession of steel-engraved labels. Used initially by French "classified growths" at the turn of the last century, steel-plate engraving still implies chateau status. Now nearly a lost art, steel engraving is used almost exclusively by governments to print monetary notes. For the finest line reproduction, no other method comes close. Note from the shadows that the time of day is midafternoon: Closer scrutiny under a magnifying glass reveals a clock face on the façade with the hands set at four o'clock.

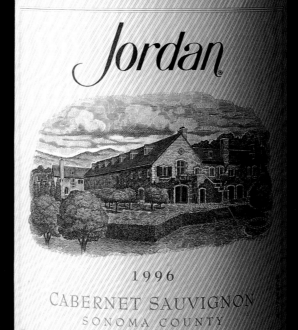

KUNDE
Sonoma Valley, California

One of the oldest continuously owned and operated family vineyards in California, the antiquarian verdigris treatment of the label reflects the time-honored heritage of these Sonoma Valley pioneers. All the design elements support the validity of the historical premise. Penman flourishes flank an engraving reproduced from an ancient bottle discovered in the farthest recesses of the winery ruins. The Kunde mark is crisply embossed on a verdigris cartouche. The date, 1879, screened into the base of the label further emphasizes the founder's pedigree.

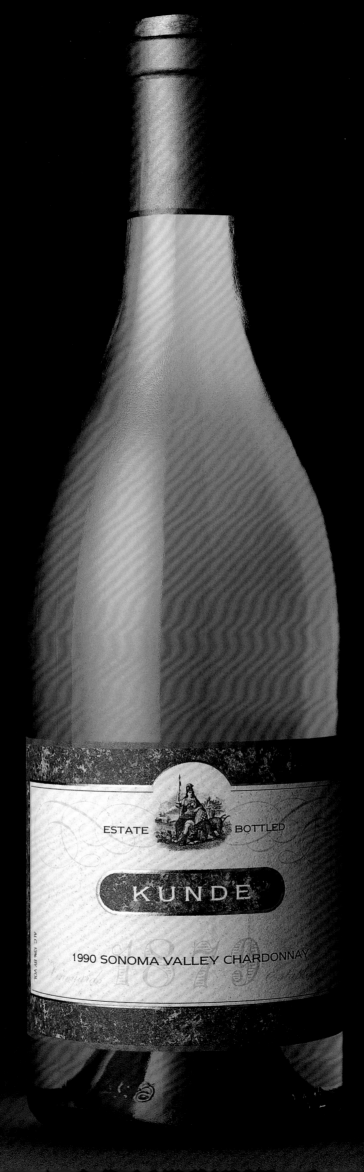

ESTATE · BOTTLED

KUNDE

1990 SONOMA VALLEY CHARDONNAY

MASSETO
Bolgheri, Italy

The design for Masseto, one of the world's most expensive wines, was selected by competition. Competing against two established European design firms, a young American designer offered a vision more classic than those steeped in generations of history and tradition could see for themselves. Using old-world Italian imagery, the coup de grâce was the designer's decision to mock up his prototype on original paper more than a hundred years old — paper that was faithfully duplicated when the label went to press.

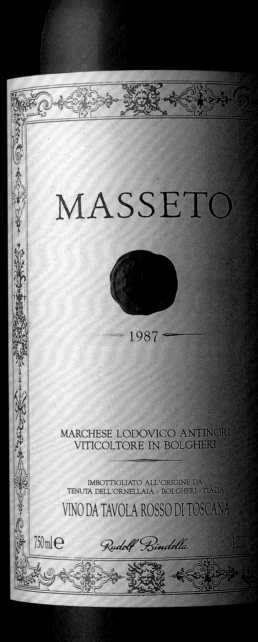

PARAS VINEYARD
Napa Valley, California

Paras Vineyard sits astride Mount Veeder like a saddle, with views east toward Sonoma, and westward to Napa Valley. The wine and viticulture is classic Francophile, except for the robust Nebbiolo that has also found a home away from home. The label seeks to reflect this commitment to traditional European elegance. The oak tree at the top of the illustration accurately replicates the terroir of this American classic, as well as evokes the home in which the wine will rest before its journey to the table.

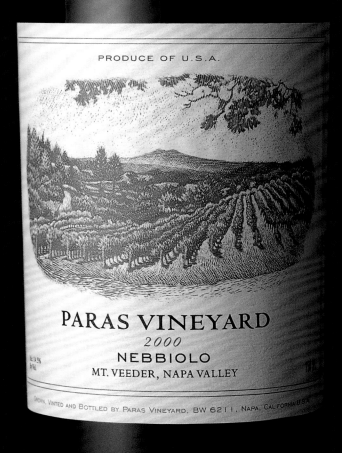

PRODUCE OF U.S.A.

PARAS VINEYARD
2000
NEBBIOLO
MT. VEEDER, NAPA VALLEY

GROWN, VINTED AND BOTTLED BY PARAS VINEYARD, BW 6211, NAPA, CALIFORNIA U.S.A.

PETER MICHAEL WINERY

Knights Valley, California

Rocky hillside vineyards at the base of Mount St. Helena are the source for Peter Michael Winery's legendary "wines with altitude." Transforming the characteristic northern California poppy—omnipresent at the estate—into a stylized mark evoking the image of an English horn, captured both the simplicity of the land, and the British heritage of the proprietor. An emotional spot of color contrasted against simple typography and roughly textured paper, the emblem serves as an identifying insignia.

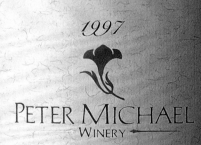

MORE OR LESS

*"Take some more tea," the March Hare
said to Alice, very earnestly. "I've
had nothing yet," Alice replied in an
offended tone: "so I can't take more."
"You mean you can't take less,"
said the Hatter: "it's very easy to
take more than nothing."*

— Lewis Carroll

CAIN FIVE

Napa Valley, California

Frequently a distinguishing mark on a label design will evolve into a brand's emblem, but in the unusual case of Cain Five, the label shape itself serves as the icon. The five-sided label, with its delicate background pattern, represents the five Bordeaux varietals that comprise each vintage blend of Cain Five. Superimposed on the dark cylinder of the tapered bottle, the absence of illustrative reference points focuses the attention on the sculptural entity of the package itself.

1997

CAIN FIVE

NAPA VALLEY

CABERNET SAUVIGNON 87%
CABERNET FRANC 11%
PETIT VERDOT 1%
MALBEC 1%

ALC. 14% BY VOL.

CASA GIRELLI "VIRTUOSO"

Veneto, Italy

The reserve wine of Casa Girelli is of singular artistic quality — hence the name Virtuoso. It is a wine that need not sing its own praises. Appearing as if dressed for the symphony, the package is a simple composition in black and white. The face labels are the essence of understatement — merely two postage stamp-sized boxes with all extraneous paper removed. Only essential information persists.

CASA
GIRELLI
Virtuoso

Primitivo
2000
Puglia

CHALK HILL

Napa Valley, California

Chalk Hill is both the brand name and geographic appellation. An exceedingly refined and elegant wine estate, the challenge was to create a design that paid worthy respect to both husband and wife proprietors who each play a significant role in managing the brand. The sculpture-embossed sumi brushwork of the central logo is set in a fabric of grey flannel, which reflects a subtle interweaving of feminine and masculine sensibilities.

Chalk Hill Clones. A self-contained seminar, the Chalk Hill Clones collection presents six different wines made from individual clones. Displayed in an exquisite custom box, and accompanied by a book discussing clone variation, the use of actual metal vineyard tags further emphasizes the field-trial nature of the selections. The main label, unadorned on a stark white stock, references the tradition of laboratory samples. In a subtle nod to style, the labels are engraved in two colors and watermarked with the individual clone numbers.

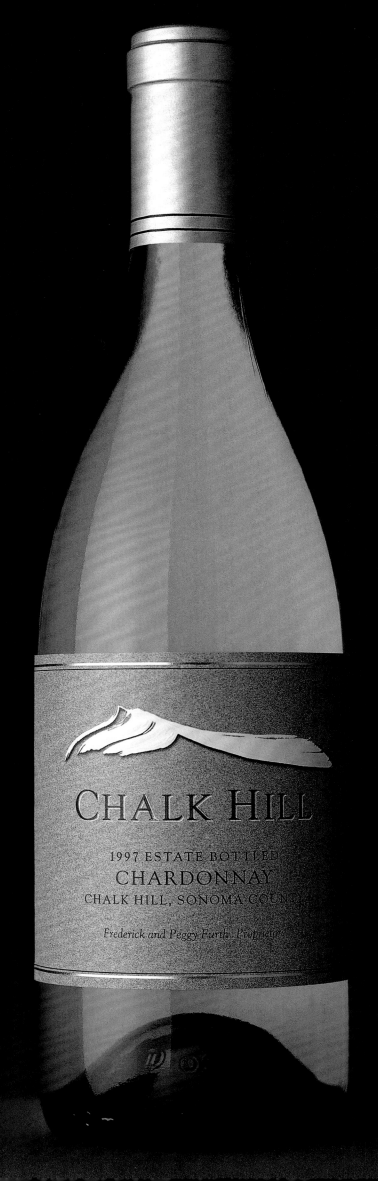

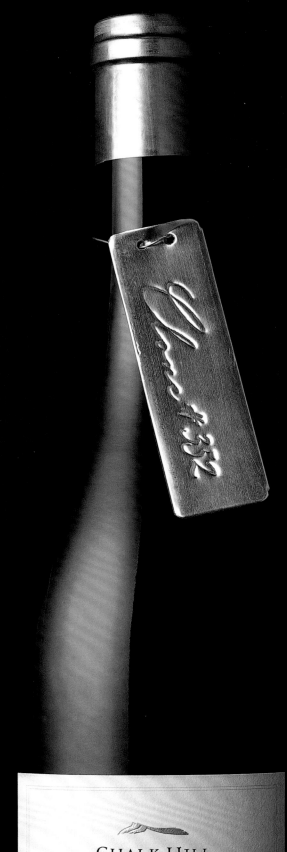

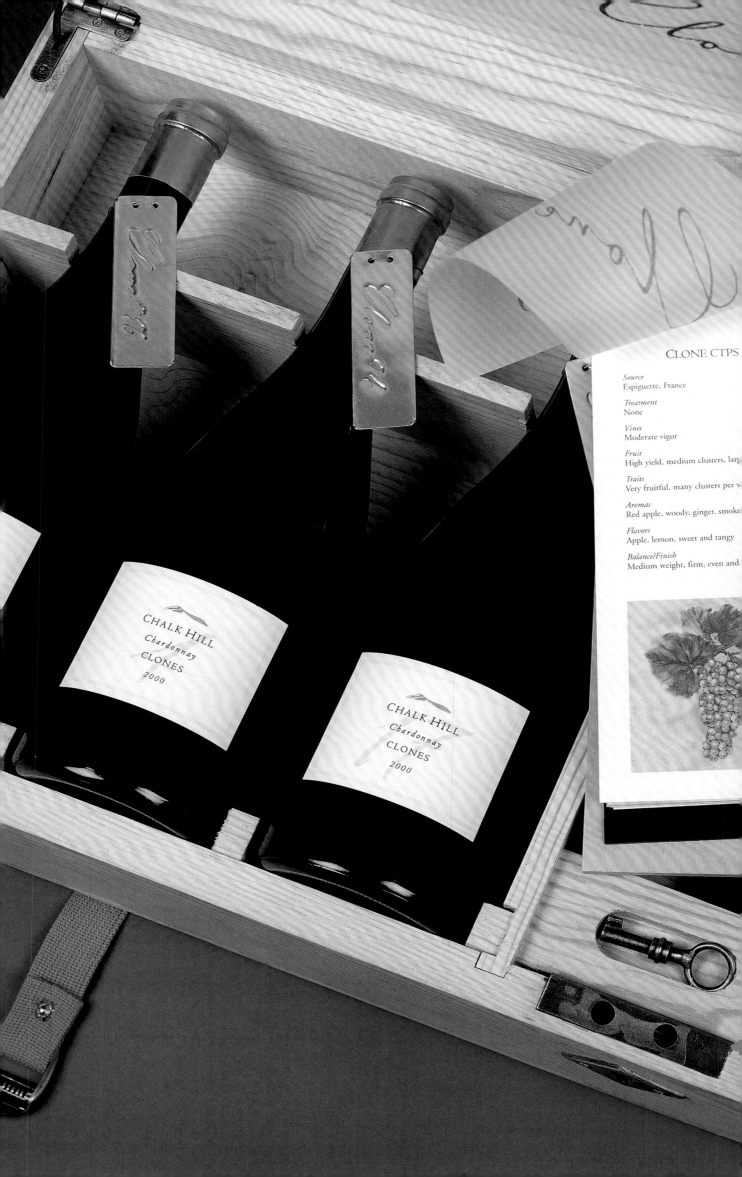

CLONE CTPS

Source
Espiguette, France

Treatment
None

Vines
Moderate vigor

Fruit
High yield, medium clusters, larg

Traits
Very fruitful, many clusters per v

Aromas
Red apple, woody, ginger, smoke

Flavors
Apple, lemon, sweet and tangy

Balance/Finish
Medium weight, firm, even and

CHALK HILL
Chardonnay
CLONES
2000

CHALK HILL
Chardonnay
CLONES
2000

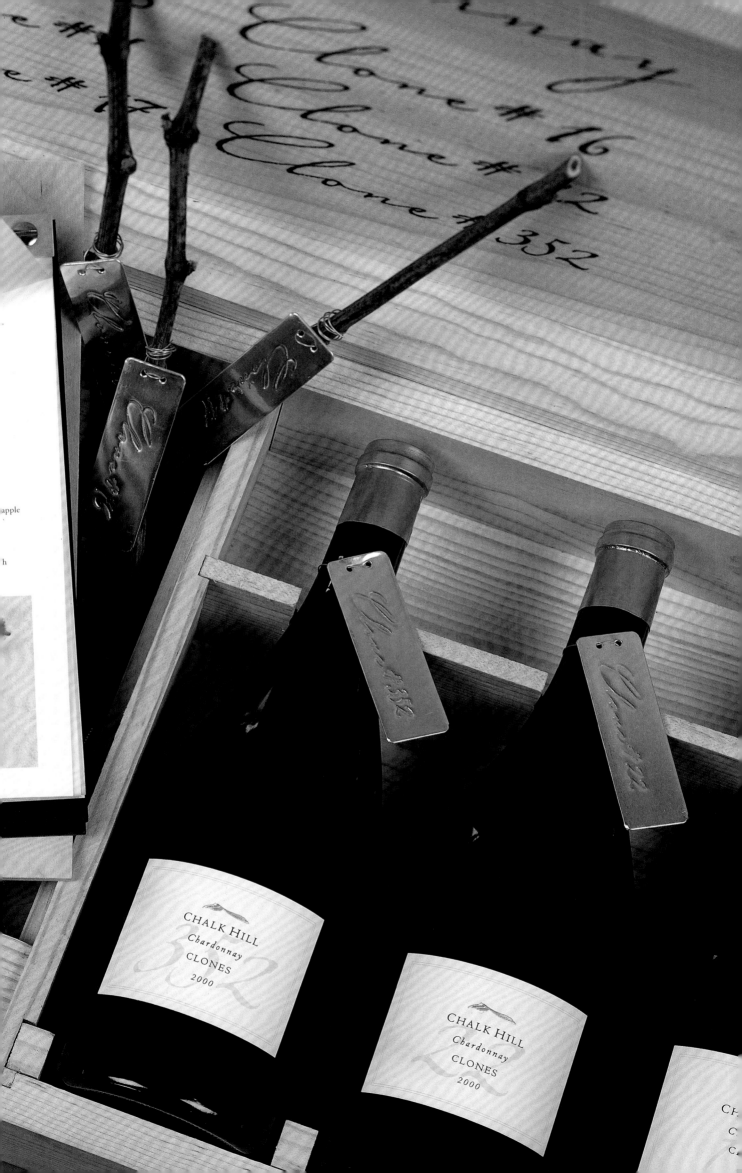

ESTANCIA "DUETTO"
Alexander Valley, California

The Estancia Duetto package focuses on the script initial *E* as an illustration in the foreground and a supportive leitmotif in the background. In embossed gold foil, the calligraphic swoop simultaneously suggests the contour of a hillside vineyard, and the ocean breezes which help create the wine's unique microclimate. The lilting, feminine curves of the script initial form a background pattern which softens and balances the predominantly masculine energy of the black and gold labels, capsule, and the bottle itself.

Estancia

DUETTO

1995 ALEXANDER VALLEY

70% Cabernet Sauvignon 30% Sangiovese

ETUDE

Napa Valley, California

The austere elegance of the Etude label entirely eschews illustration in favor of a pure blanc-et-noir homage to the grape varieties themselves and the wine's Burgundian heritage. Secure in its lack of ornamentation, the label's personality and nuance derive from the hand-lettered script and antique divider. Like the pages of a novel, or the notes in a musical score, the Etude label holds the potential of a masterpiece, with the winemaker fully capable of conducting his own symphony of the senses.

FLOWERS
Sonoma Coast, California

Dramatically understated, the absence of design on the Flowers label is a bold statement that the color and bouquet belong to the wine, not to its packaging. The imagery inspired by the name is left to each individual to invent for him or herself. A single spot of vivid orange is all that prepares the senses for the gentle explosion of flavor that fills the glass. Even subtle embossing and foil stamping are invisible, except upon close examination.

J. LOHR
Paso Robles, California

Two distinctly branded label elements coexist in this vineyard-designated reserve. The clever composition allows the vineyard to maintain top billing, while the use of script sublimates the typography to the Roman serif type of the primary brand. Further differentiation is attained by the use of geometry and color. The choice of a robust bottle with an accentuated punt— left fully visible by the label position— complements the reserve strategy.

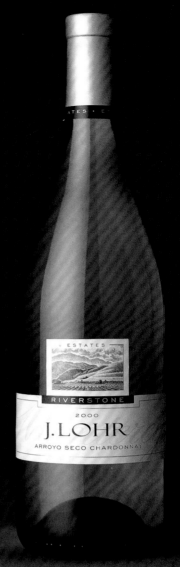

ESTATES
RIVERSTONE
2000
J.LOHR
ARROYO SECO CHARDONNAY

ESTATES
SEVEN OAKS
2000
J.LOHR
PASO ROBLES CABERNET SAUVIGNON

OLD VINES
BRAMBLEWOOD
1999
J.LOHR
LODI ZINFANDEL

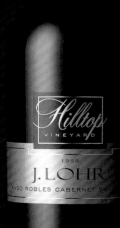

Hilltop
VINEYARD
1998
J.LOHR
PASO ROBLES CABERNET S

RAMIAN "CHAPTER ONE"
Napa Valley, California

Obviously literary, the implications of the "Chapter One" proprietary name conjure up all sorts of Dickensian visions, but the client's desire was to avoid the obvious. Instead of the product of a literary endeavor, the focus was shifted to the process, and what better to symbolize the creative process than a typewriter key. Not any old key, mind you, but that of a vintage Smith Corona circa the 1930s. Affixed with sealing wax to every bottle, the key exemplifies the concept of handcrafted, and acts as a dramatic logo for the brand. Extraneous information, such as vintage date and appellation, is relegated to an understated neckband.

TURLEY

Napa Valley, California

While it is common to reference the great wine regions of the world—Bordeaux, Tuscany, Florence— the Turley label invents its own historic tradition, an artifact from a civilization existing only in the mind. Inviting participation, it generously offers extravagant clues to its imagined past. The tendril of a vine growing from the word Turley becomes a decorative motif. Rich, dark colors suggest the wine's depth and complexity, while a low strip label shifts attention to the idiosyncratic bottle with its massive girth and sloping shoulder.

1998 LODI
ZINFANDEL
HOGTOWN VINEYARD *TURLEY*

VIÑA COBOS
Mendoza, Argentina

The muted rocky tones of the Viña Cobos label come directly from the stones of the land. Its shape refers indirectly to the region's colonial past, as does the silver foil border, but the emphasis on the sculptural unity of the entire package is more appropriately connected to the earlier indigenous cultures of the Andes, for whom sculptured containers were a primary artform. Barely discernible in the background is an engraving of the Cobos estate vineyard — the Andes looming in the distance. The narrow strip label evokes the tradition of imported wines, but with a unique placement that suggests a fresh, New World perspective.

ROCK, PAPER, SCISSORS

*Every act of creation is first
an act of destruction.*

— Pablo Picasso

BONTERRA
Mendocino County, California

Bonterra is an organically grown and produced wine from that bastion of all things organic, Mendocino County. The paper is made not from trees, but flaxseed, and the leaf illustration was taken from an actual pressed grape leaf daubed with ink. Calligraphy branding is debossed into the paper by an old-fashioned letterpress. The labels are hand-punched in small batches to attain the ripped edge, and the tin capsule, used by others, is eschewed entirely by Bonterra.

1997

Bonterra
VINEYARDS

CABERNET
SAUVIGNON
NORTH COAST

ORGANICALLY GROWN GRAPES

DOMAINE NAPA
Napa Valley, California

Drawing on the European tradition of engraving, a classically-styled illustration of the winery is presented in a contemporary context, using precision die-cutting and pinpoint registration. A specially created matte foil replicates the bronze powder patina of antiquity. The tightly tailored components cleverly juxtapose the old and new in a reference to the interrelationship of tradition and technology that is the hallmark of the winemaker's art.

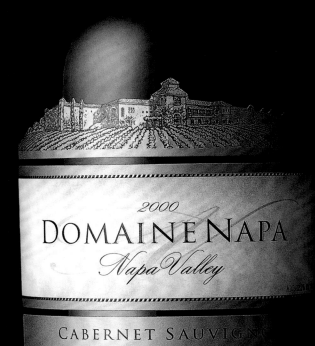

GARY FARREL

Russian River Valley, California

Wine packaging serves as a focal point capable of shaping an experience. When the winemaker extends his philosophy to the packaging, he is dressing the set, setting the scene. The Gary Farrel label, with its straightforward, no-nonsense approach, is a personal expression of the winemaker's focused precision and exceptional commitment to doing his individual best. The background color, composed of soil and rocks from the vineyard, relates the wine to the essence and richness of the land. The split label distinguishes the vineyard as worthy of distinction, casting both the winemaker and vineyard in leading roles.

GARY FARRELL

—— 2000 ——

RUSSIAN RIVER VALLEY

Zinfandel

Ricci Vineyard

MOSS CREEK

Napa Valley, California

Four generations of family have farmed this rustic hillside ranch and now the newest generation is revitalizing the old property. Simple, yet extremely kinetic, the label is a graphic symbol of the winery's new vitality. The design is a flowing three-dimensional relief in what is essentially a two-dimensional format. A mossy color palette with blind-embossed waves combine to construct the memorable illusion of an undulating creek.

Moss Creek
1995 NAPA VALLEY
ZINFANDEL

SILVERADO
Napa Valley, California

It is usually the case that the artist's original concept is the most direct and pure interpretation of the client's vision. It stems from a fresh and intense interaction with the client and is usually less encumbered by the whims of the market. The original Silverado package captures well the earthy terroir of the Stag's Leap hillside—bespeaking richness and personality. Although undergoing many reincarnations, the underlying structure of the design remains intact.

STELLA

Umbria, Italy

An Italian "star," Stella's vivid swashes of color illuminate its presence on the table. Relating the wine to the past and present in almost equal measure, the nontraditional packaging—lively and fresh—exemplifies the nature of the wine, while the medium used evokes the wine's rich cultural heritage. Inspired by the frescoes of Umbria, colors mixed in the tradition of classic fresco were applied to a limestone base by the great-granddaughter of a Sicilian fresco painter.

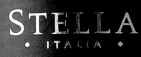

STELLA
· ITALIA ·

1997 MERLOT UMBRIA
INDICAZIONE GEOGRAFICA TIPICA

TOM EDDY

Napa Valley, California

This is the story of one man and his personal quest for perfection. The wine, totally handmade and exceptionally rare, is the essence of the rock-strewn mountain soils in which the vines grow. To replicate the vineyard terroir that means everything to Tom Eddy, handmade paper was impregnated with dirt and bark collected on a vineyard walk. The finished label is printed on recycled stock, then technically manipulated to replicate the organic texture and shape of the original paper. The chisel-debossed black foil plaque symbolizes artistic man amidst the natural landscape.

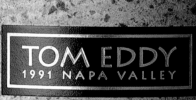

MODERN ROMANCE

Art is the accomplice of love.
Take away love and there is no art.

— Remy de Gourmant

BENESSERE
Napa Valley, California

Wishing to communicate a sense of place, this verdant oil-color landscape is an impressionist homage to the Tuscan-varietal palate of the winemaker. The painterly impact is maximized by reducing typography to a minimum—hand-lettered script knocked out of the painting, and a single line of descriptive text. The mountain profile is repeated in reverse by the cigar band, and the landscape effect is enhanced by the horizontal format wrapping around the bottle horizon.

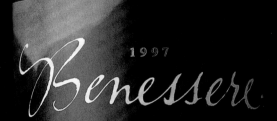

BENZIGER "TRIBUTE MIWOK"

Sonoma Valley, California

Often a label's inspiration begins with a walk through the vineyards collecting found objects that embody the essence of a place. Rocks and dirt will inspire color palettes, a leaf will influence a shape. Honoring Sonoma Mountain, and the Native American legend that reveres it as the center of the world, a piece of local obsidian became the shape for the Benziger Tribute label—an exact match in color, size, and contour. A bay leaf from the vineyard, accented with a sprinkling of gold, symbolizes the alchemy of nature.

BLANKIET ESTATE
Napa Valley, California

Unlikely clues often turn into genuine expressions of a project and its character. In this example, the family's collection of angels, and the property's resident owl, became the emblematic expressions of the family's vision and nature. Hovering enigmatically behind classic typography, the angel and owl denote a sense of place. The ornamental divider, the label's earth tones, and the spare simplicity combine to create a celestial elegance.

BRAMARE

Mendoza, Argentina

Most label designs begin with a search for clues—
objects and details of inspiration—but on occasion
the relationship works conversely and the designer car-
ries with him a favorite found object waiting to find
a home. In the case of Bramare, the photograph of a
Renaissance playing card displayed in a Venice museum
found its calling in a project that required the synthe-
sis of old- and new-world imagery, forging the link
between the wine's home in Argentina and its roots in
Italy. Refurbished with a custom color palette scanned
from vineyard rocks, the small square label emphasizes
the bottle's sloping shoulder to create a dramatic three-
dimensional sculpture.

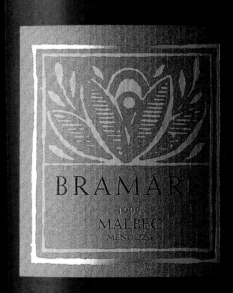

INNISKILLIN

Ontario, Canada

From frozen desiccated berries arises a wine that is sometimes called the nectar of the gods. Requiring the temperature to dip ten degrees below zero for five consecutive days, there are only two places in the world with conditions suitably severe enough to produce ice wine. Emulating this alchemy of nature, a swirling vortex effect is created by layering three metallic inks of various intensities.

Niagara Peninsula. Picked in the dead of night, with temperatures well below zero, and howling windstorms drowning out even the thunderous roar of the Niagara, ice wine truly is the world's rarest wine. Symbolized here is the grape's transmutation from frozen, hard berry to pure gold. An original steel engraving depicts the winery's landmark, a historic Frank Lloyd Wright barn.

Okanagan Valley. The petroglyph illustration pays homage to the Okanagan Valley's indigenous community, while the two-part label gives a contemporary slant to a wine from the West Coast's frontier growing region.

Crystal. The rarest of rare wines, when the season's frozen berries are finally harvested, the premium grapes are pulled aside and oak-aged for Inniskillin's luxury ice wine. Presented in a sensuous hand-blown crystal decanter, resembling an elegant perfume bottle, the only branding appears on the cork and attached booklet.

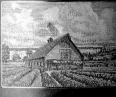

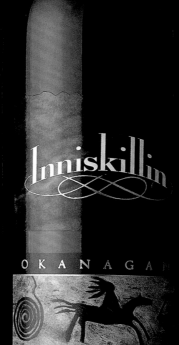

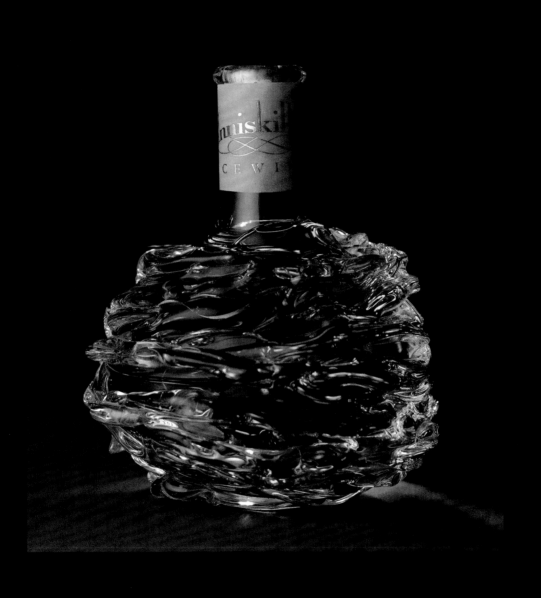

PURSUIT

Napa Valley, California

Sharing much in common, both artist and vintner
strive for perfection. Both move forward from one proj-
ect to the next, each having an inception, and each end-
ing with a final creation that the public must judge.
Their travails may read like a Louis L'Amour novel,
where you are merely the hero of your own imagination
— and only as good as your last vintage.

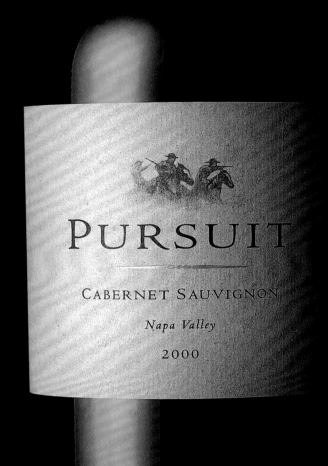

PURSUIT

CABERNET SAUVIGNON

Napa Valley

2000

ROCHIOLI

Russian River Valley, California

A traditional European approach was de rigueur for this Russian River Valley vineyard capable of producing French varietals at a world-class level. The ultimate expression of Burgundian winemaking style, the winemaker's radical focus on designating a block, not just the vineyard, made it important to balance references to both the past and present. The use of classic greens, gold accents, and an antique typeface pay tribute to tradition, while the rustic illustration of the farm and vineyard honors the wine's sense of place.

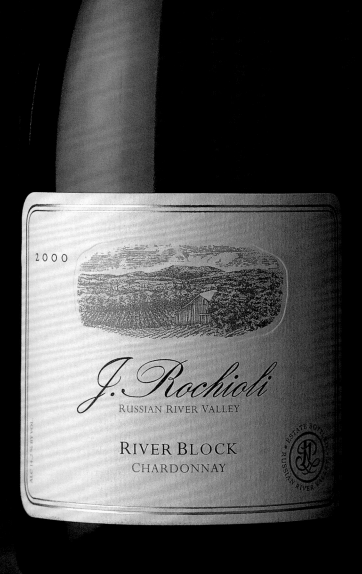

SOTER
Yamhill County, Oregon

At its heart, wine packaging tells the story of the place and the people behind a wine. Working on two levels, the design for Soter Oregon is both personal and non-specific. The illustration, based on 16th-century woodcuts, depicts the winemaker sampling the grapes while his lovely bride diligently does all the work. Look less closely, however, and the illustration stands on its own as an organic shape resembling a vine. Rich olive green tones and antique type fonts emphasize content over style in a package that is decidedly non-trendy. A little sparkle of color, and the intrinsic elegance of the naked basket closure are the only concessions to style.

VINTAGE
1998

SOTER
BEACON HILL

Brut Rosé

STAGECOACH

Napa Valley, California

Named for the stagecoach that ran through the ranch in the mid-1800s, Stagecoach is both the name of the wine, and the vast and spectacular mountain vineyard estate from which the wine is derived. Turning to history for inspiration, both the design's typography and central emblem might once have appeared emblazoned on the wooden door of those now exotic conveyances. To our modern world, it seems a simpler, more romantic era.

STAGECOACH

CABERNET SAUVIGNON

NAPA VALLEY

2000

WOLF FAMILY VINEYARDS

Napa Valley, California

Evoking a handcrafted simplicity sometimes requires employing every technical trick in the book—a plain modesty belying complex artifice. For the Wolf Family Vineyards label, procuring a suitable view of the historic Inglewood home and surrounding vineyards, then rendering it artistically, involved orchestrating a team of talent. The pastoral scene demanded no less than a helicopter pilot, photographer, illustrator, engraver, embosser, and printing specialists, working together to create an image of bucolic tranquility that could just as easily be seen in 1899 as 1999.

WOLF FAMILY VINEYARDS

NAPA VALLEY

CABERNET FRANC 60% CABERNET SAUVIGNON

BISHOP'S PEAK

San Luis Obispo, California

More than a statement, Bishop's Peak captures a lifestyle. Named for the mountain that overlooks the town of San Luis Obispo, the label expresses the identity of a region known for its rich agricultural heritage, and references the family's tradition of farming. A recognizable local landmark, imagery resembling an antique fruit crate relates the wine to the region and land with a direct, honest quality. The strong, bold graphic and dramatic colors are simultaneously traditional in their reverence to the land, and contemporary in their fun, vivid spirit.

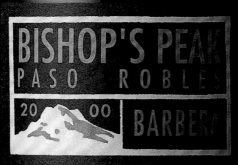

CA' DEL SOLO "FREISA"
Santa Cruz, California

An obscure Italian varietal, Freisa's primary flavor component is a remarkable effusion of wild strawberry on the palate and in the nose. Unexpected, sweet, and effervescent — Freisa is a sly seductress with the promise of a strawberry kiss. A photocopy of a scratchboard illustration hand-colored at a café table forms the foundation for the label, but the berry-colored wine itself is the dominant partner in this oenographic relationship.

Ca'del Solo

Freisa (Frizzante)
MONTEREY COUNTY - LOW ALCOHOL

ANNATA 1999
DA SERVIRE FRESCO
SERVE CHILLED

PRODOTTO DEGLI STATI UNITI

DENOMINAZIONE DI ORIGINE CONTROLLATA NET 25 FL OZ (750 ML)

CA' DEL SOLO "MALVASIA BIANCA"
Santa Cruz, California

Ca' del Solo is a mythical country located somewhere
on the border of California and Piemonte, Italy. The
Ca' del Solo labels feature a cast of characters who are
dedicated to the (solo) pursuit of causes, if not lost,
at least seriously misplaced. Its winemaking emphasis
is on eccentric Italian varietals, and this eccentricity is
reflected in the artwork, which is an eclectic melange
of cut paper, scratchboard, photocopy, and ink. In
this case, young Malvasia is on her way to her first day
of school and reaches out for her mother's hand — or
is she letting go?

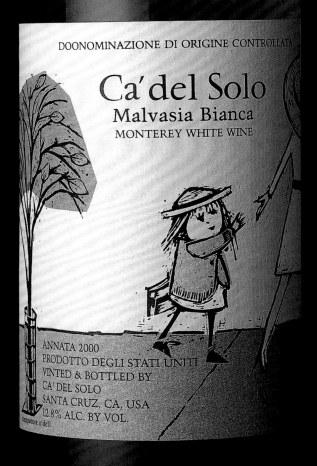

DOONOMINAZIONE DI ORIGINE CONTROLLATA

Ca' del Solo
Malvasia Bianca
MONTEREY WHITE WINE

ANNATA 2000
PRODOTTO DEGLI STATI UNITI
VINTED & BOTTLED BY
CA' DEL SOLO
SANTA CRUZ, CA, USA
12.8% ALC. BY VOL.

EAU DE VIE
Santa Cruz, California

In a process that mirrors the art of transforming grapes into wine, the designer transforms water into art. A simple framework is established — the cut potato — then nature, with its infinite range of possible combinations, is left to do the rest. French for "Water of Life," the Eau de Vie labels were made by dabbing Dr. Martin's watercolors directly onto freshly cut Idaho Russet potatoes. The pigments in the paint chemically interacted with the potato's juice to produce a subtlety of tones that no artist could ever consciously duplicate.

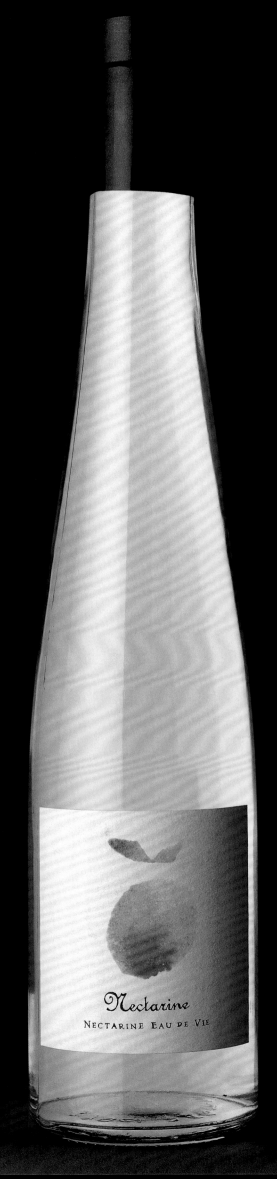

Nectarine

NECTARINE EAU DE VIE

MACROSTIE WINERY
"WILDCAT MOUNTAIN"
Napa Valley, California

Wildcat Mountain is classic Carneros: open to the elements, unpredictable, and as wild as the animal from which it takes its name. The label emphasizes a traditional commitment to excellence, at the same time reflecting the MacRostie spirit of adventure and exploration. Sculptured embossing, textured paper, and a massive antique bottle capture the authentic feel of the Carneros region — an experience that engages all the senses.

MACROSTIE

WILDCAT MOUNTAIN VINEYARD
SYRAH
CARNEROS

OAK KNOLL

Willamette Valley, Oregon

Oak Knoll belies the concept that type, and consequently the label, must be large to be readable. Luxury packaging need not shout. On what is perhaps the smallest completely legal wine label, all the type seems appropriately placed and perfectly legible. Calligraphy is used for the logotype to certify the handmade persona that is the hallmark of this Oregon vintner. A separate aureate banner proclaims the wine's reserve pedigree. Sometimes less really is more.

PRESTON WINERY AND VINEYARDS
Dry Creek Valley, California

Preston Winery and Vineyards lies at the end of West Dry Creek Road in Sonoma's Dry Creek Valley. Organic farming, a deep local heritage of Italian varietals, and the proprietor's homemade bread all combine to create a richly understated expression of Preston's time and place. The colors come from wine stains and tarragon leaves, the background texture from the cloths used to knead dough. Imagine too, the salmon fighting upstream in the waters of Dry Creek, or the cat— one of many— watching, and licking his lips.

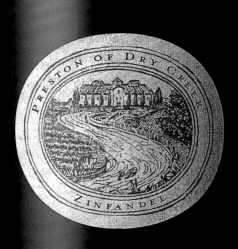

ZINFANDEL
DRY CREEK VALLEY 2000
OLD VINES / OLD CLONES

LE SOPHISTE

Santa Cruz, California

True sophistication is timeless—not particularly à la mode—so goes the tale of Le Sophiste. Random typography cut from a French newspaper gives Le Sophiste a simple and direct unity reminiscent of the late Matisse, whose Blue Nude series and jazz images were created from assembled pieces of cut paper. The prototype of the hat was cut from a Kodak film canister—an homage to Cartier-Bresson perhaps?

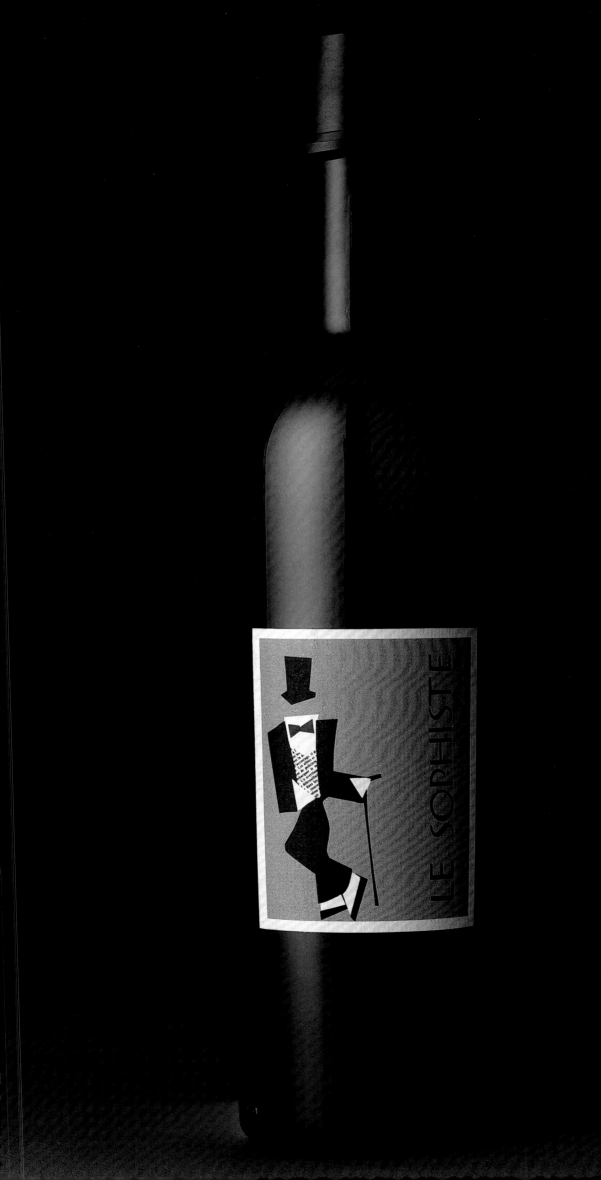

TRIA

Napa Valley, California

Tria is a partnership of three winemakers. The label is a metaphorical assemblage based on the metaphysical significance of the number three. Intentionally avoiding the obvious use of a triangle as a design element, the Roman numeral is employed as the central pillar upon which the label is constructed. The imperial theme is continued by use of the classic Roman typeface chiseled into a sanguine cartouche.

TRIA

1995 MONTEREY SOUZAO PORT

VIADER
Napa Valley, California

Rooted on the precipitous slopes of Howell Mountain, each vine in the Viader vineyard enjoys its own dramatic vista of the Napa Valley below. Considering traditional methods of illustrating the view inadequate to the task, a fine arts approach of smearing thick acrylic paint on canvas to evoke a museum-quality texture and sheen was selected instead. When the large canvas proved a chaotic mess, however, a fortuitous solution was reached by isolating and selecting an abstract 1 x 2.5-inch section — the exact size replicated on the label.

BASIC BLACK

There is no such thing
as empty space.

— John Cage

ALDERBROOK
Dry Creek Valley, California

Taking minimalism to a logical conclusion, the Alderbrook label eliminates extraneous paper. Where there is no print, there is only glass. The sensual, fluid contour of the bottle is revealed beneath floating rafts of paper. The interwoven logo, intended to signify the intersection of the three viticultural areas where the winery is situated, might as easily be divined as ripples in a brook or entwined alder branches.

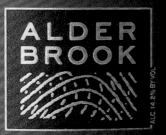

RESERVE

ALDER
BROOK

ALC. 14.2% BY VOL.

1998 CHARDONNAY
DRY CREEK VALLEY
SONOMA COUNTY

BLACK SEARS
Napa Valley, California

Not a color, black acts merely as a matte backdrop against which the tightly structured composition is pinned. While the label is rectangular, the typography is vertical, alluding to the altitude of the vineyard. The oil painting, dominated by a gnarled oak tree, provides an unexpected perspective—the view from the vine's mountaintop vantage surveying the valley below. Brooding and mysterious, the oil painting's interior view of the vineyard lends a rich, resonating elegance.

BLACK

BLACK
SEARS
— 1997 —
CABERNET
SAUVIGNON
NAPA VALLEY

HOWELL MOUNTAIN

ALC. 14.5% BY VOL.

CASA MADERO "CASA GRANDE"

Parras Valley, Mexico

On an isolated plateau, deep in the cloud-covered Sierra Madre Mountains of northern Mexico lies an impregnable fortress known as Casa Madero. Its 12-foot-thick and 30-foot-high stucco walls bear testament to the rugged construction of the conquistadors. With a pedigree dating back to 1597 when the King of Spain granted the deed to a forefather of the winery's current owner, Casa Madero is by far the oldest winery in the Americas. The original title, still bound in an ancient leather-clad book, served as inspiration for the modern brand in spirit and detail, including the aristocratic red sealing wax which caps the bottle.

Casa Grande
1993
PARRAS VALLEY CABERNET SAUVIGNON

CRICHTON HALL "REFLEXION"
Napa Valley, California

Reflexion — with an *x* — is the archaic Anglo-Saxon spelling of the word reflection, and an antique sensibility is at the heart of this label. Seeking to evoke the Victorian passion for exotic, often outrageous ornamentation, the label's vibrant extravagance puts much needed perspective on postmodern minimalism. A remembrance of things past, the Victorian spirit lives on amongst those who value fine wine, and who understand the label's potential to reflect the human spirit at its exuberant best — complex and romantic, like the wine itself.

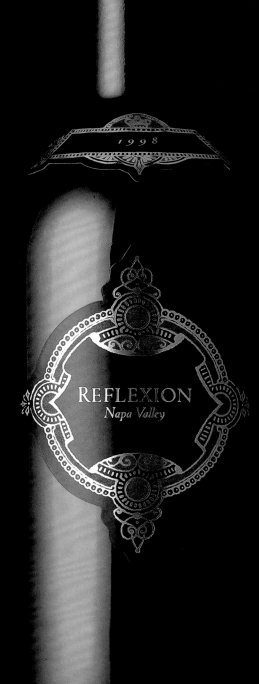

FERRARI-CARANO "TREMONTE"

Alexander Valley, California

This monochromatic label exemplifies the philosophy of understated elegance. Much like sleek formal wear, the design is utterly devoid of excess ornamentation and color — simply black with gold accents. It states its central premise — TreMonte — directly in type and emphasizes it with a graphic icon representing the same theme. The engraver's sans serif typeface was deployed as a corollary to the art deco font used in the primary Ferrari-Carano package.

VINEYARDS OF TREMONTE

FERRARI-CARANO

1996 ALEXANDER VALLEY

Chardonnay

FREIXENET
Penedes, Catalonia

Perhaps the most universally recognized wine package in history, Freixenet jealously guards the matte black bottle as a proprietary design motif. Both enigmatic and sexy, even the feel is silky to the touch. A slightly modified version of the historic family logotype lends an authentic old-world aura, while the heraldry acts as regal plumage. Complicated legal jargon has been chased to the farthest edges of the label, just beyond peripheral vision, leaving the branding unencumbered by typographic trivia.

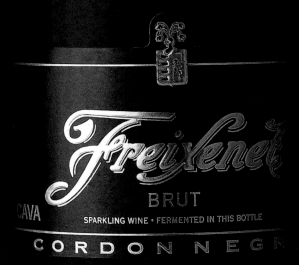

MISSION HILL
Okanagan Valley, British Columbia

High above the West Coast's Okanagan Valley, looms the mountaintop citadel of Mission Hill. Just as the monumental structure dominates the valley, so too does its presence on the bottle, enshrined in a steel engraving. It offers a sense of place for those not fortunate enough to enter its gates. Each of the three primary elements of the package displays its own label — the brand with logo on the top, the winery in the central or core position, and the proprietary wine name at the base. Even the capsule plays a significant role in defining the brand.

ESTATE

MISSION HILL
Family Estate

1998
OCULUS

PAUL HOBBS
Sebastopol, California

The original artwork for the Paul Hobbs label came from photocopies of the actual varietal leaves themselves, which were converted into silkscreen, then printed with opaque ink on black pastel drawing paper. The overall effect is more abstract than literal. The sculptural quality of the package is emphasized by the manner in which the leaves enter the field of vision at an angle, and disappear around the sides. The austerity of the Roman capitals used in the type is balanced by the jewel-like quality of satin gold foil.

1996

PAUL HOBBS

CABERNET SAUVIGNON

CARNEROS, NAPA VALLEY
HYDE VINEYARD

ALC. 13.2% BY VOL.

TERRA

Napa Valley, California

A French term representing the complex interplay of soil, geology, and climate, terroir defines the mysteriously unique character found only in great wines. This terrestrial concept inspired both the name and design of this limited-production offering. The layered tones of dark rich colors affirm the wine's intensity and depth, while a black organic pattern overlays a landscape of deep umber, adding a rocky visceral texture to the composition. The simple tri-tipped emblem represents the mountain domain from whence the wine originates.

TERRA

Napa Valley

Syrah

2000

ZIA

Napa Valley, California

A Native American word representing the primordial forces — earth, wind, fire, and rain — as well as the focus of the cardinal points — north, south, east, and west — Zia is the abstract center of a metaphysical universe: a state of mind. The design is a graphic talisman that conjures up archetypal memories. A soothing gray backdrop simulates twilight, while the red diamond, resting on a delicately balanced fulcrum, both draws the eye and points the way.

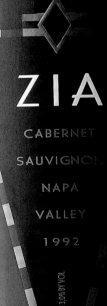

ZIA

CABERNET
SAUVIGNON
NAPA
VALLEY
1992

ALC. 13.0% BY VOL.

750

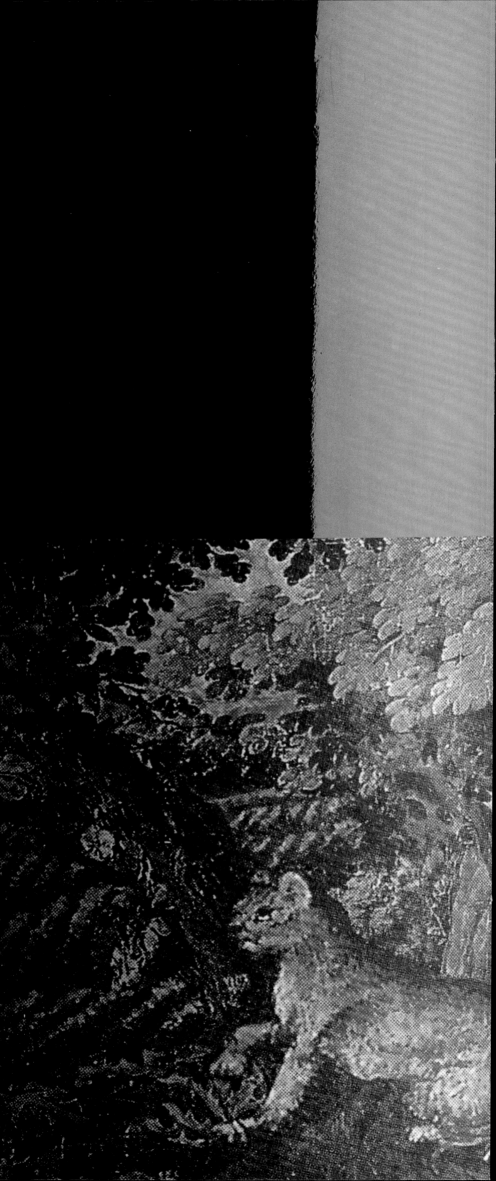

A GLASS MENAGERIE

We can shape clay into a pot, but
it is the emptiness inside that
holds the things we want.

— Lao-Tsu

ALIARA "ODFJELL VINEYARDS"
Maipo Valley, Chile

The seafaring heritage of the Norse explorers is continued by the Odfjell family, whose exploits in the shipping industry were interrupted long enough to put down vineyard roots — and a stunning architectural gem of a winery — in Chile's Maipo Valley. Transcribed from an ancient rune stone, the mythical ancestor of the family's resident Norwegian fjord horses supplies the label's imagery. Redolent of leather and rust, the New and Old World combine forces in the label, just as they do in the wine itself.

CHATEAU POTELLE "VGS"
Napa Valley, California

Situated high on Mount Veeder, the Chateau Potelle vineyards enjoy a fairy-tale atmosphere — sunny and beautiful in the clearings, dark and mysterious in the woods. In a unique interpretation of a wine label, a collage of elements were combined to create a storybook quality that would lend its imaginative support to the magic of the wine itself. Beginning with an enormous initial letter Z, the winemaker weaves a tale of Zinfandel. Elements of French tapestry, iconography from a La Fontaine fable, and the resident local mountain lion combine for a suitably mythic illustration.

*Z*infandel,
Napa Valley
produced with
natural yeast fermentation and
bottled by Chateau Potelle,
Mt. Veeder, Napa,
California.
1998 table wine.

CHATEAU
POTELLE

EMERY

Sonoma Valley, California

This three hundred acre ranch overlooks the historic town of Sonoma and resides in a yet-to-be-delineated appellation of mountainous ridge top properties that may one day be recognized as California's premier Cabernet growing region. Family proprietorship of the Emery estate includes aristocratic British lineage, and the family crest became the origin for the label's icon. The traditional heraldry dominates the label's elegantly empty space, saying little and inferring much. An unadorned crimson capsule crowns the package.

EMERY

Sonoma Valley

———

CABERNET
SAUVIGNON

2003

FOREST GLEN
Sonoma County, California

Forest Glen was the first two-part face label. A revolutionary design for its time, and a technical feat, the label preceded modern pressure-sensitive technology (which today makes aligning and applying multiple labels easy and exact) by more than half a decade. Drawing upon hunt club imagery, the package personifies the gentlemanly warmth of an oak-paneled library. American western tradition is conjured up by the oval-framed oil of a forest idyll, and references the vintner's reverence for natural habitat. All type and rules are matte gold foil, juxtaposed against a rich forest green background.

Forest Glen Sonoma Reserve. A dignified reserve package for the emblematic Forest Glen winery retains the iconic oil painting that has come to represent the brand. A narrative, detailing both appellation and pedigree, gives the label the appearance of an antique bill of lading, which lends the overall document a historical frame of reference. Generous use of paper and European ceremonial script accentuate the reserved stature of the presentation.

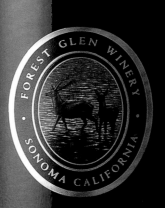

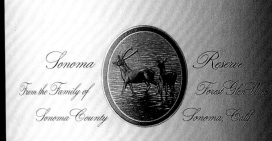

FROG'S LEAP
Napa Valley, California

The Frog's Leap label has been performing its amphibious ballet for nearly twenty vintages, classic Roman typography supplying a springboard for a leap of the imagination. It is modeled on the complex simplicity of the Zen garden: curves contrasting with angles, shades of grey texture complementing stark black and white. Always traveling, never arriving; the frog philosophically accepts its fate with the mantra, "Time's fun when you're having flies."

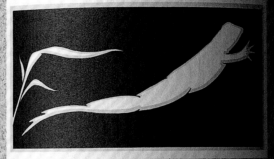

FROG'S LEAP

1983
CABERNET SAUVIGNON
NAPA VALLEY

CELLARED AND BOTTLED BY FROGS LEAP
ST. HELENA, CALIFORNIA · ALCOHOL 13.1% BY VOL.

HOWELL MOUNTAIN VINEYARDS
Napa Valley, California

The name Howell Mountain Vineyards would traditionally be considered too lengthy to treat in a vertical format, but the vineyard's spectacular mountaintop domain demanded elevation. The tall, handsome bottle shape further emphasizes a theme of verticality. Two separate summit estates are joined in the brand, and are represented here by the dancing cougar and bear, each an indigenous mascot of their respective vineyards. A romanticized oil painting dominates the apex and adds an eye-catching lightness to this otherwise deep color palette.

HOWELL
MOUNTAIN
VINEYARDS

1993

HOWELL MTN.

ZINFANDEL

NAPA VALLEY

ALC. 13.5% BY VOL.

LINGENFELDER

Pflaz, Germany

The simple joy of wine and the magnificent typo-
graphical possibilities of a name like Lingenfelder sup-
ply the setting for this label's whimsical narrative. For
generations, local birds in the Pflaz region of Germany
have found dining at the Lingenfelder family estate an
irresistible culinary delight. The illustration, opaque
gouache on black paper, depicts one of the local flock
ignoring an earthworm in favor of its stolen grape.

lingenfelder

1998 riesling

Bottled by Karl Lingenfelder D 67229 Grosskarlbach
Qualitätswein b. A L APNr. 51170501899 · Produce of Germany

Pfalz · alc. 11.5% by vol. · 750 ml.

MINER

Napa Valley, California

In a novel twist of heritage inspiring design, the vint-
ner's lineage to ancient Assyria— the birthplace of
viticulture— asserts a new definition of classic. After
much research, the winged sun disc was chosen as the
central icon, a symbol that works as well today as it
did four thousand years ago. Set at the pinnacle of the
building block-like assemblage, the symbol attains
monumental proportion. Textured paper is reminis-
cent of archeological digs, while extreme die cutting
lends an aura of Paleolithic power.

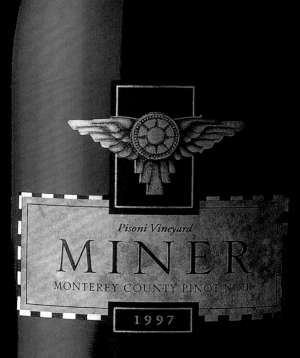

PALOMA

Napa Valley, California

Paloma reflects the dream of peace offered by a serene mountain aerie at the very peak of Spring Mountain. A labor of love, Paloma, the Spanish word for dove, embodies the proprietors' love of the land, and love for one another. A single superlative variety is produced and displayed as an integral part of the composition. This allows the white dove to attain ascendancy in the visual hierarchy. The typography is derived from a turn-of-the-century foundry-style book, and lends a distinctly Western flavor. The entire design is created by a silkscreen and firing technique, which render the paper label obsolete.

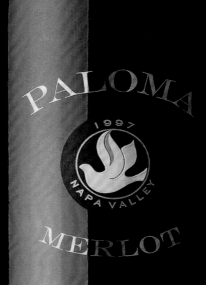

STAG'S LEAP WINE CELLARS

Napa Valley, California

Warren Winiarski's stunning victory in the legendary Paris tastings of 1976 helped set the stage for California's entrance onto the world-class wine producing scene. A reinterpretation of this classic and historic package—and a humble homage to the French heritage that formed the foundation for its spectacular success—makes this an American original with roots in the soil of Bordeaux. The austere simplicity of the single-color printing is a dramatic contrast to the luxurious glass embossing, which was one of California's first.

STAG'S LEAP WINE CELLARS

S.L.V.

CABERNET SAUVIGNON
NAPA VALLEY

1997
ESTATE
BOTTLED

PRODUCED AND BOTTLED BY
STAG'S LEAP WINE CELLARS, NAPA, CA
ALC. 14.5% BY VOL.
CONTAINS SULFITES

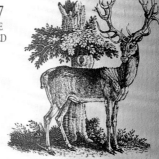

WARREN WINIARSKI

APPENDIX

The Devil whispered behind the leaves,
"It's pretty but is it Art?"

— Rudyard Kipling

AEROS

Goosecross Cellars

Jeffrey Caldewey

1992

Oil painting

8.6 cm x 2.4 cm

Paper, forged nickel and bronze

Page 76

ALDER BROOK

Jeffrey Caldewey

1998

Scratchboard

4 cm x 5.6 cm

Offset lithography, foil, emboss

Page 230

ALIARA "Odfjell Vineyards"

Chuck House

2000

Ink

9 cm x 5.4 cm

Offset lithography, foil

Page 252

ARAUJO ESTATE WINES

Chuck House

1993

Pen and ink

9.4 cm x 13.5 cm

Lithography, gold & clear foil, emboss

Page 118

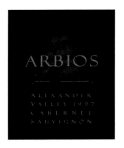

ARBIOS

Jeffrey Caldewey

1991

Woodblock stamp

5.6 cm x 7.3 cm

Applied ceramic and 18k gold

Page 58

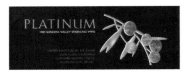

B.R. COHN "Platinum"

Chuck House

1986

Ink, handmade paper

16.2 cm x 6.2 cm

Offset lithography, foil, emboss

Page 78

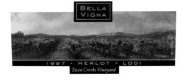

BELLA VIGNA

Jeffrey Caldewey

1997

Pastel over Polaroid die transfer

12.6 cm x 5.7 cm

Offset lithography, foil, emboss, die-cut

Page 80

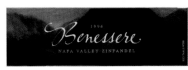

BENESSERE

Jeffrey Caldewey

1998

Oil, pen & ink

16 cm x 5.3 cm

Offset lithography, foil

Page 184

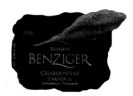

BENZIGER

Chuck House

1997

Obsidian, bay leaf airbrush

8.7 cm x 6.5 cm

Offset lithography, foil, emboss, die-cut

Page 186

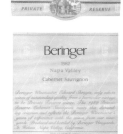

BERINGER

Jeffrey Caldewey
with Ralph Colonna & John Farrell

1982

Steel engraving

10.4 cm x 14 cm

Offset lithography, foil, emboss, die-cut

Page 120

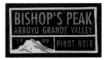

BISHOP'S PEAK

Chuck House

2000

Pen & ink

7.3 cm x 4.2 cm

Offset lithography

Page 208

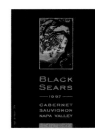

BLACK SEARS

Jeffrey Caldewey

1999

Oil painting

6.4 cm x 9.2 cm

Lithography, foil, emboss, spot varnish

Page 232

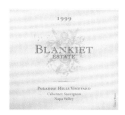

BLANKIET ESTATE
Chuck House

2001

Pen & ink

8.2 cm x 7.8 cm

Offset lithography, foil, emboss

Page 188

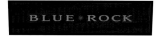

BLUE ROCK
Jeffrey Caldewey

2002

Pen & ink

11 cm x 2.7 cm

Lithography, metallic inks, embossing

Page 82

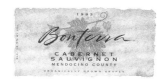

BONTERRA
Jeffrey Caldewey with Dan Maclean

1993

Leaves, ink, handmade paper

10.8 cm x 5.4 cm

Vegetable inks, flaxseed paper, die-cut

Page 168

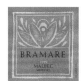

BRAMARE
Chuck House

2001

Ink

5.8 cm x 6.4 cm

Offset lithography, foil, emboss

Page 190

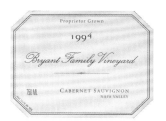

BRYANT FAMILY VINEYARD
Chuck House

1995

Hand lettering

10.8 cm x 8.3 cm

Lithography, 3 foils

Page 122

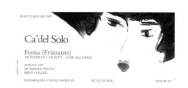

CA' DEL SOLO "Freisa"
Bonny Doon Vineyard

Chuck House

2000

Scratchboard and colored pencil

12 cm x 5.6 cm

Offset lithography

Page 210

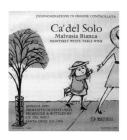

CA' DEL SOLO
"Malvasia Bianca"
Bonny Doon Vineyard

Chuck House

1990

Scratchboard, cut-paper

9.7 cm x 11 cm

Offset lithography

Page 212

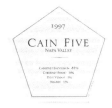

CAIN FIVE
Chuck House

1992

9 cm x 9 cm

Offset lithography, foil, emboss

Page 142

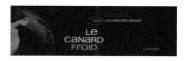

LE CANARD FROID
Bonny Doon Vineyard

Chuck House

1993

Photograph, airbrush

26 cm x 5.4 cm

Offset lithography

Page 84

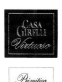

CASA GIRELLI "Virtuoso"
Jeffrey Caldewey

2002

Pen & ink

4 cm x 8 cm

Offset lithography, foil, emboss

Page 144

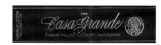

CASA MADERO "Casa Grande"
Jeffrey Caldewey

1993

Pen & Ink

12 cm x 3.2 cm

Offset lithography, foil, emboss

Page 234

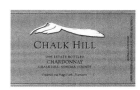

CHALK HILL
Jeffrey Caldewey

1989

Sumi brush & ink, grey flannel

13.2 cm x 8.4 cm

Offset lithography, foil, emboss

Page 146

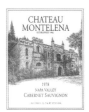

CHATEAU MONTELENA
Jeffrey Caldewey with Sebastian Titus

1974

Pen & ink

8.8 cm x 11.8 cm

Offset lithography

Page 32

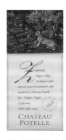

CHATEAU POTELLE "VGS"
Chuck House

1992

Ink, gouache, photocopy, photography, cut-paper, watercolor

6.2 cm x 13.8 cm

Offset lithography, foil, emboss

Page 254

LE CIGARE VOLANT
Bonny Doon Vineyard
Chuck House

1986

Ink, cut-paper, airbrush

12.1 cm x 10.5 cm

Offset lithography

Page 98

CRICHTON HALL "Reflexion"
Chuck House

2000

Ink

13.7 cm x 16 cm

Offset lithography, foil

Page 236

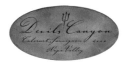

DEVIL'S CANYON
Jeffrey Caldewey

2002

Crow quill pen & ink, blow-torch

8 cm x 4 cm

Ceiling wax, lithography, die-cut

Page 124

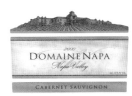

DOMAINE NAPA
Jeffrey Caldewey

2002

Pen & ink

10.5 cm x 7.5 cm

Offset lithography, foil, emboss

Page 170

EAU DE VIE
Bonny Doon Vineyard
Chuck House

1992

Dr. Martin's Synchronous Watercolors, potato print, hand lettering

5.6 cm x 6.2 cm

Offset lithography

Page 214

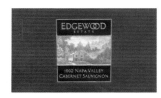

EDGEWOOD
Jeffrey Caldewey

1994

Wood-cut engraving

12.8 cm x 7.7 cm

Offset lithography, foil, emboss

Page 126

EL FELINO/LA FELINA
Chuck House

2001

Ink

6.8 cm x 11.5 cm

Offset lithography, foil

Page 86

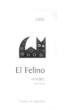

EL MOLINO
Jeffrey Caldewey

1982

Stone lithography

12.7 cm x 8.5 cm

Offset lithography

Page 34

EMERY
Jeffrey Caldewey

2002

Brass engraving

8.3 cm x 12.3 cm

Offset lithography, foil, emboss

Page 256

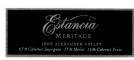

ESTANCIA
Chuck House

1996

12.7 cm x 8.5 cm

Offset lithography, foil, die-cut, emboss

Page 152

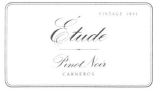

ETUDE
Chuck House

1985

Hand lettering

12 cm x 8.2 cm

Offset lithography

Page 154

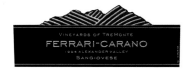

FERRARI CARANO "Tre Monte"
Jeffrey Caldewey

1996

Torn paper, pen & ink

14 cm x 5.4 cm

Lithography, foil, emboss, die-cut

Page 238

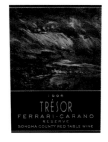

FERRARI CARANO "Tresor"
Jeffrey Caldewey

1998

Oil painting by Marco Sassone

8.2 cm x 11.8 cm

Offset lithograhy, foil

Page 60

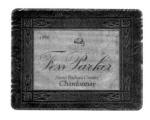

FESS PARKER
Jeffrey Caldewey

1991

Leather, handmade paper, pen & ink

10 cm x 7.9 cm

Offset lithography, foil, emboss

Page 36

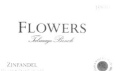

FLOWERS
Chuck House

1993

Ink

12.3 cm x 6.4 cm

Offset lithography, foil, emboss

Page 156

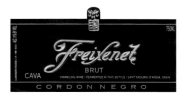

FOREST GLEN
Jeffrey Caldewey

1991

Oil painting

10 cm x 8.2 cm

Offset lithography, foil, emboss

Page 258

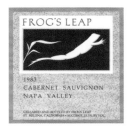

FREIXENET
Jeffrey Caldewey

1998

Black glass, cut-paper

12.6 cm x 6.7 cm

Lithography, foil, emboss, die-cut

Page 240

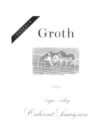

FROG'S LEAP
Chuck House

1984

Ink

10.1 cm x 10.5 cm

Offset lithography

Page 262

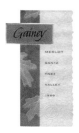

GAINEY
Jeffrey Caldewey

1999

Oak leaves, handmade paper

6.5 cm x 11.5 cm

Lithography, foil, emboss, die-cut

Page 102

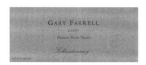

GARY FARRELL
Chuck House

2001

Sandpaper & ink

11.3 cm x 5 cm

Offset lithography, foil, emboss

Page 172

GROTH
Jeffrey Caldewey

1995

Steel engraving

8.4 cm x 12.7 cm

Engraving, foil

Page 128

GUNDLACH BUNDSCHU "Vintage Reserve"
Chuck House

1985-2000

Multi-media

23.8 cm x 13.3 cm

Offset lithography, foil

Page 38

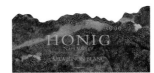

HONIG
Chuck House

1999

Watercolor, ink, cut-paper

14 cm x 7 cm

Lithography, foil, emboss

Page 62

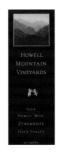

HOWELL MOUNTAIN
Jeffrey Caldewey

1991

Oil, pen & ink

4.7 cm x 14.3 cm

Offset lithography, foil, emboss

Page 264

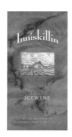

INNISKILLIN
Jeffrey Caldewey

1998

Steel engraving

6 cm x 12.6 cm

Lithography, metallic inks, emboss

Page 192

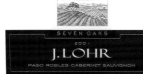

J. LOHR
Jeffrey Caldewey

1996

Pen & ink

11.6 cm x 6.5 cm

Lithography, foil, emboss, die-cut

Page 158

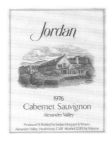

JORDAN
Colonna, Caldewey & Farrell

1976

Steel engraving

9.3 cm x 12.3 cm

Engraving

Page 130

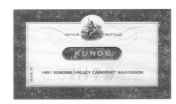

KUNDE
Jeffrey Caldewey

1988

Anodized copper, steel engraving

13 cm x 7.7 cm

Offset lithography, foil, emboss

Page 132

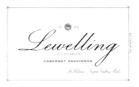

LEWELLING
Jeffrey Caldewey

1995

Pen & ink

9.7 cm x 6.3 cm

Offset lithography, foil, emboss

Page 42

LINGENFELDER
Chuck House

1999

Gouache

5 cm x 9.3 cm

Offset lithography

Page 266

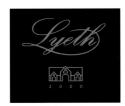

LYETH
Jeffrey Caldewey

1982

Pen & ink

8 cm x 7 cm

18k gold ceramic

Page 64

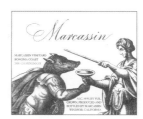

MACROSTIE
"Wildcat Mountain"
Chuck House

2002

Watercolor, ink, cut-paper

11.4 cm x 8.1 cm

Offset lithography, deboss, foil

Page 216

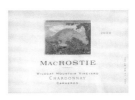

MARCASSIN "Circe"
Chuck House

1993

Hand lettering, antique engraving

11 cm x 9.4 cm

Offset lithography

Page 104

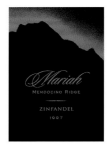

MARIAH
Chuck House

1997

Airbrush

5.5 cm x 7 cm

Silkscreen on glass

Page 66

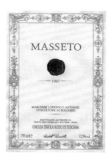

MASSETO
Chuck House

1989

Antique lettering, engraving

9.4 cm x 13.8 cm

Offset lithography, foil, emboss

Page 134

MINER
Jeffrey Caldewey

1996

Cut-paper, limestone

7.2 cm x 6.4 cm

Offset lithography, foil, emboss

Page 268

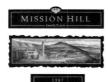

MISSION HILL
Jeffrey Caldewey

1999

Charcoal

7.3 cm x 6.7 cm

Lithography, foil, emboss. die-cut

Page 242

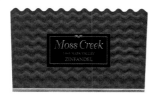

MOSS CREEK
Jeffrey Caldewey

1999

Cut and creased paper

12 cm x 7.7 cm

Lithography, foil, emboss, die-cut

Page 174

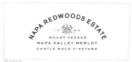

NAPA REDWOODS ESTATE
Jeffrey Caldewey

2000

Pen & ink

11 cm x 5.3 cm

Engraving

Page 484

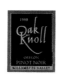

OAK KNOLL
Jeffrey Caldewey

2000

Pen & ink

5.5 cm x 6.8 cm

Offset lithograhy, foil, emboss

Page 218

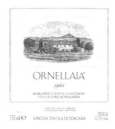

OLD TELEGRAM
Bonny Doon Vineyard
Chuck House

1988

Airbrush, antique typewriter

12.2 cm x 10.6 cm

Offset lithography, emboss

Page 46

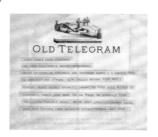

ORNELLAIA
Chuck House

1987

Engraving by R. Swartley

9.2 cm x 10.7 cm

Offset lithography, foil, emboss

Page 48

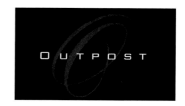

OUTPOST
Chuck House

2000

15.2 cm x 9 cm

Silkscreen on glass

Page 68

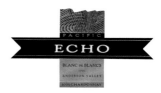

PACIFIC ECHO
Jeffrey Caldewey

1998

Fingerpaint

12.5 cm x 7.3 cm

Lithography, foil, emboss, die-cut

Page 106

PACIFIC RIM "Riesling"
Bonny Doon Vineyard
Chuck House

1998

Ink, watercolor, photography

12.2 cm x 7.7 cm

Offset lithography

Page 70

PALOMA
Jeffrey Caldewey

1996

Pen & ink

5 cm x 5.5 cm

Applied ceramic and 18K gold

Page 270

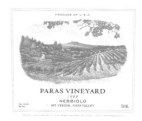

PARAS VINEYARD
Chuck House

2001
Scratchboard by Sharon Neil Williams
12 cm x 10.3 cm
Offset Lithography
Page 136

PAUL HOBBS
Chuck House

1989
Ink, foil on black drawing paper
13 cm x 7.7 cm
Offset lithography, foil
Page 244

PEPPERWOOD GROVE
Jeffrey Caldewey

2001
Cut-paper
3.6 cm x 13.1 cm
Lithography, foil, emboss, die-cut
Page 88

PETER MICHAEL WINERY
Chuck House

1989
Ink
10.4 cm x 9 cm
Offset lithography, foil
Page 138

POGGIO ALLE GAZZE
Chuck House

1987
Airbrush
10.1 cm x 10.1 cm
Offset lithography
Page 90

PRESTON WINERY & VINEYARDS
Chuck House

2002
Ink, bread-cloth
5.8 cm x 5.2 cm
Offset lithography
Page 220

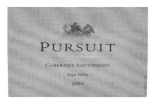

PURSUIT
Jeffrey Caldewey

2001
Charcoal
11.6 cm x 7.7 cm
Offset lithography, foil
Page 196

RAMIAN
Jeffrey Caldewey

2002
9 cm x 3.5 cm
Offset lithography
Page 160

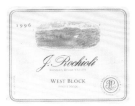

ROCHIOLI
Chuck House

1991
Ink, watercolor wash
10.2 cm x 8.3 cm
Lithography, foil, deboss
Page 198

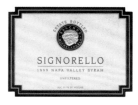

RUSACK
Jeffrey Caldewey

2002
Ceramic tile, cut-paper
9.6 cm x 6.2 cm
Offset lithography, foil, emboss
Page 92

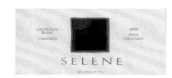

SELENE
Chuck House

1993
Scratchboard, cut-paper
13.3 cm x 6 cm
Offset lithography, foil
Page 108

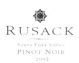

SIGNORELLO
Jeffrey Caldewey

1992
Pen & ink
11 cm x 8.2 cm
Lithography, foil, emboss, die-cut
Page 94

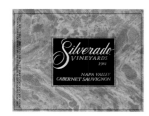

SILVERADO
Jeffrey Caldewey

2002

Opaque watercolor

11.8 cm x 9.4 cm

Offset lithography, foil, emboss

Page 176

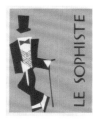

LE SOPHISTE
Bonny Doon Vineyard

Chuck House

1990

Cut-paper, hand lettering, newsprint. Capsule/top hat: mold injected plastic

6.8 cm x 8.6 cm

Offset lithography

Page 222

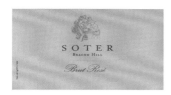

SOTER
Chuck House

2001

Ink

12.5 cm x 7 cm

Offset lithography, foil

Page 200

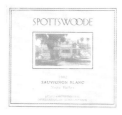

SPOTTSWOODE
Chuck House

1986

Pen & ink illustration by Otto Hessemeyer

12 cm x 11.2 cm

Offset lithography, foil

Page 50

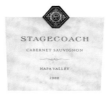

STAGECOACH
Jeffrey Caldewey

2002

Steel engraving, pen & ink

9.6 cm x 8.4 cm

Lithography, foil, emboss, die-cut

Page 202

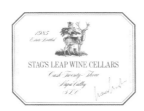

STAG'S LEAP WINE CELLARS
Chuck House

1985

Antique Engraving

12.5 cm x 10 cm

Offset lithography

Page 272

STAGS' LEAP WINERY
Jeffrey Caldewey

1997

Pen & ink

5.4 cm x 11 cm

Offset lithography, foil, emboss

Page 52

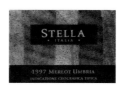

STELLA
Chuck House

1997

Fresco on limestone by Tina Ficarra

8 cm x 5.7 cm

Offset lithography, foil

Page 178

TERRA
Jeffrey Caldewey

2002

Hot wax & volcanic ash

9.2 cm x 12.7 cm

Offset lithography, foil, emboss

Page 246

TOM EDDY
Jeffrey Caldewey

1992

Dirt, bark and handmade paper

12.3 cm x 9 cm

Lithography, foil, emboss, die-cut

Page 180

TRIA
Jeffrey Caldewey

1996

Cut-paper

8.2 cm x 5.6 cm

Lithography, foil, deboss, die-cut

Page 224

TURLEY
Chuck House

1994

Ink

13.2 cm x 3 cm

Offset lithography, foil

Page 162

TURLEY ROUSSANNE
Chuck House

1994

Ink

13.2 cm x 4.2 cm

Offset lithography, foil

Page 110

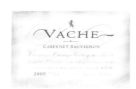

VACHE
Jeffrey Caldewey

2002

Pen & ink

10.4 cm x 7 cm

Offset lithography, foil, emboss

Page 54

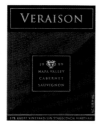

VERAISON
Jeffrey Caldewey

2001

Cut-paper, pen & ink

7.8 cm x 10.6 cm

Offset lithography, foil, emboss

Page 112

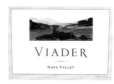

VIADER
Chuck House

1992

Acrylic on canvas

9.2 cm x 6.7 cm

Offset lithography, foil, emboss

Page 226

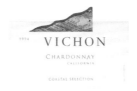

VICHON
Chuck House

1993

Acrylic, various organic materials:
fabrics, juices, herbs, spices.

10.5 cm x 7.3 cm

Offset lithography, foil

Page 72

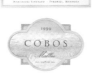

VIÑA COBOS
Chuck House

2000

Photoengraving

8 cm x 7 cm

Offset lithography, foil

Page 164

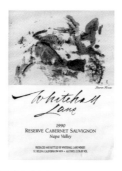

WHITEHALL LANE
Chuck House

1988

Melted wax crayon by Lauren House
Hand lettering by Barbara Harris

9.3 cm x 13.7 cm

Offset lithography

Page 114

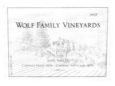

WOLF FAMILY VINEYARDS
Chuck House

1999

Pencil drawing by Mike Gray
9.4 cm x 6.8 cm

Offset lithography, foil, sculpted
emboss

Page 204

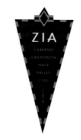

ZIA
Jeffrey Caldewey

1992

Cut-paper

5.3 cm x 11.6 cm

Lithography, foil, emboss, die-cut

Page 248

ACKNOWLEDGEMENTS

Jeffrey Caldewey and Chuck House would like to acknowledge the generous help and talent of the following individuals whose commitment made this book possible.

Editing: K. Page Sparhawk

Photography: Robert M. Bruno

Production: Samantha Smith

Jeffrey Caldewey would like to thank the following talented individuals who played a role in creating the collection of work presented in this book:

Maryann Agnew, Jeff Beauchamp, Ralph Colonna, Georgia Deaver, Jim DeCrevel, Paul DeCrevel, Rhonda Diaz, John Farrell, Mike Gray, Lynelle Heuschober, Cynthia Kirk, Dan Maclean, Mandy Masciarelli, Ronna Nelson, Holli Scheumann, Lorinda Scotland, Samantha Smith, Robert Swartley, Sebastian Titus, Courtney Turman, Nicole Vernon

Chuck House would like to thank:

Jeffrey Caldewey, Ralph Colonna, Lance Cutler, John Farrell, Tina Ficarra, Stephan Finke, Carol Gillot, Mike Gray, Barbara Harris, Kathryn Havens, Lauren House, Aurora Noel, Wes Poole, Dick Schieck, Kyla Schwaberow, Leanne Schy, Robert Swartley, Tom Tennies, Sebastian Titus, Tom Todd, Sharon Neal Williams

Photo Credits
Page 15: Robert Partridge: The Ancient Egypt Picture Library
Page 16: (c) Werner Forman/Art Resource, NY

CONTACT INFORMATION

Icon Design Group represents the combined talent, experience, and philosophies of designers Jeffrey Caldewey and Chuck House. To learn more about ICON Design Group, visit www.icondesigngroup.net.